T0157930

Also by Dr. Gary A. Thomas

Try Again: Help is On the Way

New Birth Pentecostal Book of Discipline

How to Reach the Author:

Dr. Gary A. Thomas can be contacted by sending an email to garybronx@aol.com, which will be forwarded.

LIFE AT GROUND ZERO

GARY THOMAS

WestBow
PRESS
A DIVISION OF THOMAS NELSON

Copyright © 2013 Gary Thomas.

All rights reserved. No part of this book may be used or reproduced by
any means, graphic, electronic, or mechanical, including photocopying,
recording, taping or by any information storage retrieval system
without the written permission of the publisher except in the case
of brief quotations embodied in critical articles and reviews.

Unless otherwise identified, Scripture quotations are
from the King James Version of the Bible.

WestBow Press books may be ordered through booksellers or by contacting:

WestBow Press
A Division of Thomas Nelson
1663 Liberty Drive
Bloomington, IN 47403
www.westbowpress.com
1 (866) 928-1240

Because of the dynamic nature of the Internet, any web addresses or
links contained in this book may have changed since publication and
may no longer be valid. The views expressed in this work are solely those
of the author and do not necessarily reflect the views of the publisher,
and the publisher hereby disclaims any responsibility for them.

Any people depicted in stock imagery provided by Thinkstock are
models, and such images are being used for illustrative purposes only.
Certain stock imagery © Thinkstock.

ISBN: 978-1-4908-1901-3 (sc)
ISBN: 978-1-4908-1902-0 (hc)
ISBN: 978-1-4908-1900-6 (e)

Library of Congress Control Number: 2013922224

Printed in the United States of America.

WestBow Press rev. date: 12/20/2013

Contents

For his anger endureth but a moment; in his favour is life: weeping may endure for a night, but joy cometh in the morning.—Psalm 30:5

Be strong and of good courage, fear not, nor be afraid of them: for the LORD thy God, he it is that doth go with thee; he will not fail thee, nor forsake thee. —Deuteronomy 31:6

Dedication

To people dear to me:
My family
Sophia Thomas—my wife
Lorima Thomas—my son

Those who have taught me well:
My parents
Samuel Thomas
Naomi Thomas

To the memory of my mentors:
Rev. & Mrs. Lorima Uluiqavarau
Mr. & Mrs. Virginia Campbell

I thank all my brothers and sisters, my colleagues in ministry, my church family at New Birth Pentecostal, and all my precious friends whose prayers, stories, experiences, and advice have provided me with fertile ground for reflection. It is my prayer this book will be a source of encouragement and blessing to all who read it.

Preface

You cannot say with certainty where you will be five or ten years from now. You do not know if you will be prosperous or poor, honored or despised, have many friends or only a few. The world faces uncertain days, and it always has. It is no surprise that most of Scripture was written in times of crisis and adversity because so much of life is lived in the face of danger.

When I was a child, I wanted to become a lawyer, but I had a conversion experience at age twelve that altered the course of my life. While living on the sunny island of Jamaica, I attended college, but there was still a void that my quest for knowledge did not fill. I attended a traditional Methodist church, where I felt a call to the ministry. Eventually, I migrated to the United States where I would enroll in college, seminary, and a doctor of ministry program. Along the way, I worked at a hardware store. I married, taught anthropology at a university, become a high school history teacher, and was pastor a church that went from 7 to 150 members in less than three years. All these factors shaped the story I tell in this book.

I have grown as a Christian to believe that God is for you! Your parents may have forgotten you, your siblings may be embarrassed by you, your enemies may have the upper hand on you, and the world may seem against you, but God is for you!

This book will assist all God's children no matter their place in life to learn they don't have to settle for less than all God has promised them.

Chapter 1

When There Is Nothing

And said to his servants, go up now and look toward the
sea. And he went up, and looked, and said, there is nothing.
And he said, go again seven times. —1 Kings 18:43

Webster defines *nothing* as something that does not exist. Another
name for nothing is zero. In 1 Kings 18, Elijah prayed for a drought,
and the drought came and stayed for three and a half years, and tens
of thousands starved to death as punishment for their idolatry. After
they repented, after Baal's priests were dead, God send down the
much-needed rain. Elijah knew every drought has a beginning and
an end.

There are droughts that come to all of us as individuals, as a
church, or even in our ministries. In this drought, Elijah suffered
like everyone else. In 1 Kings 17:7, we read his brook dried up, but
he knew it would not last forever.

The message here is that life at ground zero is dry, and many
Christians are facing their droughts today; their spiritual beings are
thirsty, and others are spiritually barren. However, one day—and
it's already on God's calendar—a hurricane from heaven is going to
blow your way and the rain of heaven will flood your soul. Your
drought will be over.

1

"For there is a sound of abundance of rain" 1 Kings 18:41. It had to be hot in that desert where Elijah and his servant were, maybe over a hundred degrees. Dead grass crunched under their feet, and dust flew up with each step they took. Most of the cattle and sheep had died; a few that had somehow survived were leaning up against a fence post, so skinny you could count every rib. Droughts bring malnourishment, weakness, and great susceptibility to disease. In the middle of this, the man of God said he heard the sound of an abundance of rain. You know what he was saying? "Right now, there's nothing, but on the other side of nothing, I hear something!"

That man or woman of God who is in tune with heaven and hears the Devil say, "I'm going to destroy you—you will die in the drought" will rise up and say, "No! I hear the sound of abundance of rain. I'm coming out and up. God will deliver me, and I will praise Him." Elijah said that it wasn't a sprinkle, it wasn't just a little shower, it was an abundance.

According to the Bible, nobody heard the sound except the prophet—not even his servant. God will let you know when your rain is coming. Get ready! Right now, it's being made up in the heavens, and at the appointed time, it will rain down on your life, your situation, your marriage, your family, your ministry, and your job. If God can find someone who will put his or her ear to the ground, someone to listen, He said He would send it! Ahab, get ready. The rain is coming. Prepare yourself. Before you see it, you will hear it. We are living in a day when it is reversed. We say, "Show me something, and then I'll believe it." God says, "Believe, and then I will show it to you."

Jesus told Thomas that blessed are those who had not seen yet believed. "But preacher," some will say, "if I could just see God raise a dead man, I'd believe it." You better believe God can raise a dead

man if your eyes never behold it. "I'd believe God can heal cancer if I could just see it once!" You had better believe it if you're lying on your deathbed with cancer. For He said He was the Lord who heals and that by His stripes we are healed. Job said, "Though He slays me yet will I trust Him" Job 13:15. You may not have had your rain yet, you may not have seen your miracle yet, and you may not have received your answer yet, but believe! See it in your spirit, and you will behold it in your flesh.

In verse 43, Elijah told his servant, "Go up. Look." The servant came back and said, "There is nothing." Did Elijah pout? Kick the dirt? Throw himself a good old temper tantrum? God had already told Elijah He was going to send rain, yet Elijah had to pray seven times before he saw even a cloud. Servant, Go! He came back with a report of nothing. Go again! Six times, he got the same report: "There is nothing."

Nothing. Don't you know the Devil was playing with Elijah's mind? "You went and told Ahab that God was sending rain, but now nothing's happening. You didn't really hear from God. This drought will continue." When we get in a drought, we get in our closet and pray. We live the best lives we can. We read, study, pray. We go to church faithfully, work for God, pay tithes, and yet the answer is still *nothing*. Is it any better? No! Are you healed? No! Has the situation changed? Yes. It looks like it's gotten worse.

It is a drought! You go to church and get nothing. The preacher preaches, and you get nothing. Singers sing, and you get nothing. You hold on in faith nonetheless. You send faith to the hilltop of your difficulty. What do you see? Nothing. You pray again and meet with God, yet there is nothing. Six times you send your faith up that mountain, yet nothing, nothing, nothing. But Isaiah says, "They that wait upon the Lord shall renew their strength. They shall mount up with wings as eagles. They shall run and not be weary.

They shall walk and not faint" Isa. 40:31 You send your faith up the mountain the seventh time, and now, on the other side of nothing, is something!

I am talking to you by faith. On his first six trips, Elijah's servant may have wondered why in the world he had to keep this up. "How long will it last? How many more times can I make this trip and come back disappointed? I've asked God that question many times, and I don't have an answer."

The Word of God tells me to hold onto God, to keep on climbing, praying, and looking. There will come a day when I will see a cloud and then rain. This drought will end. The blessings of God will fall. My seventh time will come. The clouds will gather, the wind will blow, and the rain will fall on me. Verse 45 says that there was a great rain. "People of God, hold on! Make that seventh trip up that mountain and by faith look toward the sea and God is going to show you something." That servant could testify today, "Six times did I go up that mountain and walked back down empty-handed, but the seventh time, God showed me a cloud. I saw the glory, I saw the presence of God, I saw what I needed to know, that God was about to move."

We will all experienced spiritual frustration, but we must all keep on going. We have all tried to outrun it, outpray it, outgive it, and outlove it, but it is still there. One of Satan's greatest tactics is to try to wear you down. He thinks if he can send people away empty handed enough times, they will quit. He told God he could discourage Job enough, cause him enough pain, and frustrate him enough that he would curse God to His face. However, through it all, Job sinned not, nor did he charge God foolishly. I've heard people say, "I'm going to quit church because when I go, I feel nothing." I've heard others say, "I'm going to quit seeking the Holy Ghost because I just can't get it" or "I'm going to quit paying my tithes because I

give and give but there's just not enough." I've also heard, "I'm going to quit this or that because I have tried it and it doesn't work." You know where they are? They're on their third, fourth, fifth, or sixth trips up that mountain; if they would just hold on, press on, climb one more time, they would find out that God has blessings with their names on them!

I'm ready for the rain to fall; I'm ready for the other side of nothing. I've got my ear tuned to heaven, and I believe I hear the sound of abundance of rain. We Christians know what it's like to go through droughts, but they're coming to an end; God will send us rain.

Where there is nothing, we should still have faith. Such was the case in 2 Kings 6, where we read how a prosperous nation and a blessed group of people were at rock bottom. The people of Israel were serving a God who provided for all their needs. He made them the head and not the tail. He gave them enough so they would not become beggars, but their disobedience changed all that. They found themselves at a crossroad, up against pressure, frustration, and problems that seemed bigger than them. Their disobedience had led to an invasion; the Syrians captured Israel and put the city of Samaria under siege. As a result, there was a shortage of food, and its price skyrocketed. A donkey's head, we're told, went for eighty silver shekels, while a quarter pint of dove's dung went for five shekels. This was a high price to pay for unclean and forbidden meat under Jewish laws.

In those desperate days of the famine, the text mentioned two women who were down to zero. Life was at its lowest for them; they were starving. We're told one of them killed her son and made a meal that she shared with the other woman, who promised to kill her son for the same reason the next day. The starving woman who had killed her son learned the other woman had hid her son.

This starving woman must have been crying "Unfair!" Longing for justice, the woman brought her case to the king, who was walking on the city wall.

The situation made the king sick to the heart, but rather than repent of his own disobedience and failure to follow the Lord and accept the famine as God's judgment, he looked for a scapegoat and found Elisha. He vowed to put Elisha to death. Instead of vowing to pull down the altars of the pagan gods in Samaria, the king swore to kill the prophet of God. The king sent a messenger to seize and behead Elisha, but God revealed the king's scheme to Elisha before the hit man arrived. Elisha had men to block the door until the king showed up at his house.

The king and Elisha met. The king was convinced there was no way out of the famine; things were looking helpless. Surrendering to the Syrians was probably an option for the king, but Elisha told the king to repent and wait on the Lord for deliverance. The unbelieving king, however, was ready to throw in the towel.

In the midst of the severe famine, God revealed to Elisha in 2 Kings 7:1 that the end of the famine was one day away. The inflation was about to end in twenty-four hours. God was about to come true for a people whose backs were against the wall. A sudden deliverance was about to take place in Samaria. The king didn't believe it, nor did one of his officers, who ridiculed Elisha's words. When things become totally impossible, however, God is still in charge. When we are down to zero, that's the time God is getting ready to end our famine. When the church is down to zero, that's when we can expect people to flock to the church.

Revival usually comes to a church when it's down to zero. Miracles can take place anytime, but most often, miracles happen when we're down to zero. Doors will open, but usually when we're down to zero. It doesn't matter how many zeros are in our lives, the

equation is about to be changed. God is getting ready to put numbers before all our zeros.

As valueless as a zero may be, you can't do business without it. Millionaires know who they are because of the zeros behind their money. As well, you can't do math without zeros. You can't be a successful Christian without having some of those zero moments in life. Even when a situation seems too much for you, God's Word still stands; your zero days are over! The drought is over. The bareness is over. The earthly king of Israel was not god; God is. I am sure many reading this book are going through zero moments, ready to throw in the towel because their lives are at zero points. I write to remind you that you have twenty-four hours before the end of your famine.

God's grace is sufficient for any setbacks or trials He allows to come into our lives. Failure is not always the consequence of sin. God is in control of our lives, so we may not understand why sickness, sorrow, heartache, and pain come our way, but we can be certain God knows about it and has allowed it in our lives for a purpose.

We have no barrier of hardened steel around us to protect us; we encounter failures and disappointments because we are children of God. Our failures come to strengthen our faith. In our times of tears, God has promised to help and comfort us. Just as the night has a limit, so there is a limit to what God will allow our faith to suffer (1 Corinthians 10:13). In our nights of tears, God says, "This far and no further" (Job 1:12; 2:6).

The cross of Christ is an example of exactly what it means to experience loss. The crucifixion was the most shattering spiritual and psychological event the disciples ever suffered. All their dreams seemed dashed by their wicked rulers and pagan Romans who drove those cursed nails. The disciples indeed wept that night as they had never wept before, but their joy came on the resurrection morning.

Despite all they had been told, they had not in their wildest dreams envisioned the glorious resurrection. The darkest night was turned to the brightest day that Sunday morning.

What's causing your zero today? Is it something you can neither change nor modify? Some failures and disappointments come with severe adversity to our faith, but they come to test our faithfulness and commitment to the gospel of Christ, and we will have every bit of sorrow turned into joy in eternity. Tears will be cleared from all eyes. No sobs will be heard ever again, and no one will hurt anymore (Revelation 21:4). Are you looking forward to that day, or do you find yourself attached to your failures on earth? It's about time you begin spending time each week thinking about what the joys of heaven will be like.

God can turn your failures into success stories. He can allow you to have a foretaste of His ultimate joy when He turns your failures in the night into joy by morning. He did so with Jacob, who wept bitterly over the supposed loss of Joseph. But in the "morning," his joy knew no bounds when he learned his beloved son was alive, a leader in Egypt, and would live with him and his children. God turned Job's cold night into a morning of joy by doubling all he had (Job 42:12). Hannah's depression and bitterness because of her childlessness was turned into the joy of giving birth to six children, including a son who led Israel as prophet, judge, and priest.

Our duty during the nights of failures is to keep on faithfully trusting God. Even if it looks as if everything is out of control, we are to be faithful and not despair because God will come to our rescue. During those tear-stained nights, we must look to God in honesty, knowing we may not know why our failure is happening but trusting that God knows why.

The tests that come to many of us are severe. Some have lost their children, while others have gone from great wealth to poverty,

and still others have been taken sick. God has not promised His children will be exempt from hurts and failures of earthly life, but He has promised to be with them to sustain them and grant them eventual victory.

We often feel discouraged at times, but God is getting ready to turn our nights of failures into mornings of joy and success. All true Christians know there is nothing more important in life than living life for the Lord. As we go through life each day, we should be mindful that God has our future in His hands. It doesn't matter what crisis we are going through, we should still have an attitude of thanksgiving to God.

Habakkuk, one of the twelve minor prophets in the Bible, praised God's wisdom even though he didn't fully understand His ways. He held on to the promises of God regardless of what was happening to him.

> Although the fig tree shall not blossom, neither shall fruit be in the vines; the labor of the olive shall fail, and the fields shall yield no meat; the flock shall be cut off from the fold, and there shall be no herd in the stalls: yet I will rejoice in the Lord, I will joy in the God of my salvation. The Lord God is my strength. (Habakkuk 3:17–19)

The circumstances of Habakkuk's life appeared to contradict God's revelation concerning His power and purposes. Habakkuk struggled in his faith when he saw men flagrantly violating God's law and distorting justice on every level, never fearing divine intervention. He wanted us to know why God allows this growing iniquity to go unpunished. When God revealed His intention to use

Babylon as His rod of judgment, Habakkuk was even more troubled, because that nation was more corrupt than Judah.

Although Habakkuk loved his people and country that were under the wrath of God's punishment, he accepted God's answer to his problems and trusted Him even in the worst of circumstances. We too must trust God at all times because He is a God of wisdom and power. God's plan is always perfect, and nothing is big enough to stand in the way of its ultimate fulfillment. The failure of your night will soon be changed into the joys of the morning. Have faith in God. Don't give up on His promises.

Chapter 2

When a Mother Is Down to Zero

We are usually afraid of the symbol zero because of its negative connotation. For students, zero means they have not passed the test. For people looking at their bank accounts, it means there's no money left. Zero means nothing, but the life of any true mother could not exist without it.

A mother is the abundance of gifts she receives from the hands of the Lord. A mother is more than someone who gives birth to a baby. Proverbs 31:10–31 brings the notion of a good mother to the forefront and sings her praises through some fabulous, classic descriptions. A mother is a virtuous woman. She has modest behavior that leads others to Christ. She is kind to other people and gives her best without expecting anything in return. She offers godly advice and brings up her children in the fear and admonition of the Word of God.

I grew up with a mother similar to the one described in Proverbs 31. The only difference was that my mother had firsthand experience with the concept of zero in her life. Throughout my childhood and into the latter half of my twenties, my mother had a sickness that brought her to ground zero.

My mother's pain and agony was so severe that I once thought she wasn't going to see me graduate from high school. Sickness has caused many to doubt the existence of a loving God because it is

not immediately apparent that sickness can be His will; people tend to judge and blame God for it. However, we must be honest and recognize that much suffering and sickness is caused by accident, and a simple injury and even death can arise from accidents at home, at work, and on the street. Some sickness we cannot explain, but it may cause Christians to be reduced to zero before they develop a mature faith in God.

The experience of a mother being stalled at ground zero due to ongoing sickness was an inescapable fact of my life. While growing up, I wrestled night and day to arrive at an answer as to why a good woman such as my mother had to suffer so much sickness. It took me a long time before I read Paul's observation in Romans 8:28, which begins with "The sufferings of this present time" and ends with the assertion that God's love in Christ is all powerful. This Scripture bridged the gap between my weakness of faith and God's love.

When I was growing up, I used to hear people say that if we lived good lives, we would prosper, and if we were wicked, we would suffer, but my mother's sickness proved otherwise. To many, suffering is God's judgment for sin (John 9:2). A person who fell ill and broke his leg asked his pastor, "What have I done to deserve this?" To the same pastor in the same week, a man said, "I have lived a good life, and therefore God has prospered me." Sickness, pain, and misfortune are too frequently regarded as retribution.

Good people often suffer, a fact my mother's experience taught me. We also know wicked people often suffer. While for most of us sickness is fortunately limited to our age, for many it is a daily companion. My mother was puzzled and distressed by her almost forty years of daily sickness she had done nothing to deserve.

My mother was a seamstress in a small village, Desire, in Jamaica, where she lived out the words of John Wesley: "Do all the good you can to all the people you can as long as you can." She carried

out most of her work without asking her customers for money. In addition, she was an expert at her work. People sought her because of her love for God and her professionalism. Even to this day, I have clothes my mother made for me. She did her work with a spirit of willingness and patience. Later in her life, she discovered it was going to take the same willingness and patience to endure her many years of sickness.

My mother's sickness began like this. She had sewn some clothes for a poor lady in the village. My mom told her she did not have to pay her for the clothes, but the lady insisted that my mother come see her to get some money, and my mother did so one sunny Sunday afternoon. Instead of telling my mother she did not have the money to pay her, the poor lady went outside to lament at the grave of her deceased parents; she invoked their spirits to trouble my mother for some forty years down the line. This poor lady probably did not know she had no business crying for the help of the dead to aid her in paying her debt, but the result was disastrous. Even before the woman went back in her house, demons from hell had already been invoked, and enraged, they broke loose on my mother. In a matter of seconds, over thirty cats in all sorts of colors and sizes appeared.

The sight of these cats terrified my mother. She ran, screaming for help. Several of the poor woman's neighbors came to her aid, but this did not stop these demoniac cats from making noises and attacking my mother. Starting that Sunday evening, my mother came down with a severe illness and was making a wheezing sound like the cats made. From that time forward, anytime my mother was about to get ill, the wheezing sound in her chest sounded like that of a crying cat.

She was rushed off to a nearby hospital, and the next day, she was transferred to a more prestigious hospital. Despite several tests the doctors conducted, they could not diagnose her illness, and some

told her she was going to die. This was not alarming to my mother, though, who often told us she was not afraid of death. Her life, like that of Saint Paul, was hidden in Christ Jesus.

After she got out of the hospital, she was advised to move to a different neighborhood, but she refused, saying she was not afraid to suffer for Christ. And she did suffer. I remember her sitting up in bed almost every night and crying because of a severe pain in her chest. I remember when my mother was sick for three weeks and unable to get proper rest. She fell into a coma that lasted many hours. I was sixteen at the time and still vividly remember the large crowd that gathered at our house and my brothers and sisters making phone calls to America, England, and other parts of the world to inform family and friends of my mother's coma, which many had taken for her death. Yet it was for the glory of God; when my mother came out of the coma, her first words were, "Don't worry. God will take care of me."

The Devil had tried to kill my mother by giving her a cup of sickness from which she drank for over forty years, but she refused to go to a voodoo or a witch doctor; she waited on God for her change. Not knowing how soon God would come to her rescue, I prayed for the restoration of my mother's health for years.

Even the day before we came to the United States, my mother was ill, and many people told her it was not wise to go, but she insisted on it. We had a safe trip from Jamaica to the United States, which has been home for us for the past twenty-one years.

I thank God that upon entering the United States and without even setting foot in a doctor's office, my mother's health was restored, and today she is healed. This is a miracle I can't explain. I don't know if location—taking my mother from ground zero to one of wholeness—was a factor, but my mother was healed, and I can joke with her that the demons were not strong enough to follow her to

the States. God can heal sick mothers, even those who are at ground zero, in His own time.

Many have been tortured and tormented for their faith (Hebrews 11:36–38). Illness and pain come to people of excellent character. We must look at the life of Jesus for help in this problem. He chose to suffer because He knew the heart of God was one of everlasting, righteous love. According to the purposes of God, my mother believed in God for her help. She knew from day one help was on its way. She also accepted God's way of life with the assurance that with her own experiences with sickness, God was working together with her for good.

My mother's sickness was not something that had slipped out of God's grasp and had become uncontrollable; it was in His firm, guiding hand. My mother's experience with sickness showed us that there are great promises of God in which suffering may have a place; those who love the Lord know nothing in their lives can "break loose" from the grasp of God. Nothing, not even sickness, is purposeless and chaotic, because all things work together with ordered meaning for God.

In our sicknesses even at ground zero, God is always on our side. The Holy Spirit also helps us in our infirmity (Romans 8:26). God intercedes with groaning that cannot be uttered because He is the same comforter, the same helper, the same advocate God has promised to send. He is the one who gives strength. "If God be for us, who can be against us?" (Romans 8:31). Nothing in the world can defeat the purposes of our loving God, not even sickness that will bring us down to ground zero.

The Value of Your Zero

I learned from my mother how God can use affliction for others' salvation. My mother's illness led many people to Christ, and it

strengthened my walk with God. Christ healed the sick, blind, lame, dumb, those afflicted with leprosy, and those beset by demons. In so doing, He showed that God is against sickness and suffering. He has been the inspiration of vast numbers of doctors, nurses, and social workers. God deliberately chose a way of suffering for Himself to bring redemption to humankind through the suffering of His Son and has inspired a multitude of sufferers who have given over their sickness and suffering into God's hands.

Jesus also made it clear to Peter that He must suffer (Matthew 16). He gave Himself to pain, grief, torture, and the cross because He believed God's will could be accomplished in no other way. Isaiah 53 offers a picture of His life in its use of the words *despised, rejected, stricken, smitten, wounded, bruised,* and *oppressed.* Jesus deliberately plunged into the deepest depths of human anguish to carry the love of God there. That love is for all of us who are sick, tired, weak, frustrated, and encumbered with the cares of this life.

God wants to help mothers overcome their sickness. He came to be the Savior of mothers because mothers are sinners, just as everyone else is. Jesus knows when mothers are sick, and He is ready to give mothers healing and minister through them and to their children. Let us continue to pray for our mothers—they need God's help. Lift them up in prayer each time you pray. Let us be grateful for our mothers, particularly those who are sick. Even before I knew how to read, my mother's life was the first Bible I read. Thank God for mothers at ground zero!

Chapter 3

Life on Zero Lane

As a pastor and public school teacher, I meet many people who are down and out, despondent, depressed, and discouraged by one or more of life's many possible downturns. Many have lost their jobs, homes, families, and friends, and their lives have spun out of control to the point that some have considered suicide. They are living under siege, held hostage by misfortune and circumstances.

The story in 2 Kings 4 is about a poor widow whose life had been reduced to zero. She did not know what to do or where to turn. In her pain and her poverty, she did the thing she knew she could; she turned to the Lord. When she did that, God came through for her in a very big way!

God knows about all the zeros in our lives, and it's just a matter of time before He starts to put a number in front of those zeros. God knows just when to intervene. In the life of this widow, there were four zeros.

The Zero of Despair

We are told the widow was weeping uncontrollably. Her heart was broken. She was at a low point in her life. She was in deep despair.

The Zero of Death

The widow's husband, her provider, had died.

The Zero of Debt

She couldn't pay her bills; her creditors were on the verge of enslaving her sons so they could work off her debt.

The Zero of Devotion

In spite of her despair, the death, and the debt, she held firm to her faith. She needed help, but she didn't turn to her family or friends or look for a loan. In her desperation, she turned to God for help.

If you have never been down Zero Lane, look for it; it's a road every true believer must walk. It's a long and lonely road, but the widow was not walking it alone. When this widow was down to nothing, God was ready to provide for her. The prophet Elisha asked this woman two questions we must answer as well: What do you need? What do you have?

The woman didn't have much in the house; everything was running on empty, but God was ready to make provision for her. She was told to borrow from her neighbors all the empty vessels she could. The woman and her sons filled one vessel after another with what little oil they had until every vessel was full. She had begun that day with nothing, zero, but she ended the day with everything! That's what our God can do. He is able to meet our every need. He can change a zero into $1,000 or $1,000,000, or $1,000,000,000 worth of blessings.

When you are down to zero, it's usually a time of crisis, but that's really the hour that God comes to the rescue of His people. Yes, there may be despair, death, and debt in your family just as it was in the widow's life, but you should never let go of your devotion;

hold on a little longer! Still take God at His word because He will come true for you!

Like the widow, we all face frustrations on a daily basis that bring us to zero. Our problems are often short term, more nuisances than anything else. The car breaks down, we're late for an appointment, or a usually healthy baby gets a cold or the flu. Sometimes, our frustrations are of a greater magnitude; we may worry about paying the rent or how to resolve a conflict threatening our marriage. Regardless, we can usually do something about most of the frustrations we face; we can take concrete action to overcome whatever hurdle is in our way. We can get our car fixed, we can get medical care for our baby, or we can try marriage counseling. Such frustrations, big and small, we can handle with our ingenuity, resources, and courage.

Another variety of frustrations, however, can on occasion afflict us; they are the kind we can't do anything about in spite of our efforts, creativity, or fortitude. Some frustrations admit to no answer, no escape.

Swept up by the rolling flood at a Thai resort, Australian mom Jillian Searle could not hold on to her twenty-month-old and her five-year-old and survive the swirling, debris-strewn torrent. She knew she had to let go of one of her sons. But there was the question: which son to save? ("Mom's Desperate Choice: Which Son to Save," *Daily News,* December 31, 2004, p. 5).

As I thought about the struggles of the widow whose life approaching that zero, I think about my father, in ministry for over forty-three years. For many years, my father's congregation had flourished, and he hadn't worried about paying the church's mortgage or its other bills. However, the day came when he was nearing zero. The congregation had diminished, and the church needed major repairs to avoid major fines. Tenants who rented some

church facilities were refusing to pay their rent. My father received a foreclosure notice on the church.

For my father, that was a life at ground zero. This leads me to ask what happens to a person who is consistently frustrated, who finds himself or herself trapped by circumstances? One method my father used to combat the problems he faced was prayer. Prayer is very essential when you're at ground zero. My father prayed always, and he called on other sincere Christians to pray with him. In the height of all the troubles in his church, he remained the same—a calm and humorous pastor. When asked what was going to happen to the church, he responded, "God will make a way."

Can you say this when your life reaches rock bottom? What do you do when there's no way out? When you face a frustration bigger than you can handle and don't know which way to turn, is there anything more you can do besides cry, complain, or be cynical?

The good news of the gospel is that with God there is always a way out, that God never closes a door without opening a window. My father is an honest pastor who ministered with justice and compassion. He led the people to worship God rather than the many false gods out there, including materialism and popularity. Because of his exemplary life, God blessed him with long life, prosperity, and peace.

There will be times when we find ourselves face to face with a life at ground zero unlike any we have confronted before. Our enemies will join forces to attack our ministries, and many times they will be those who are very close to us and can cause us a multitude of troubles. There will be times in our ministries when we will feel badly outnumbered by the forces of our enemies and surrender will seem a feasible alternative, but because of our Christian character, we cannot surrender. Look out for the times when there will be no

way out; that was Dad's problem. What situations do we face from which there appears to be no escape? At some time or another, all of us find ourselves feeling confused, frustrated, and helpless. What do we do when there is no way out from ground zero? My father had found himself in a situation from which there seemed no escape, and he had felt confused, frustrated, and helpless. Despite his frustration, however, he had learned over his years of being a pastor that more important than anything else in a difficult situation is *perspective*. He expressed his perspective by saying "God will make a way for His people." Even though my father had his back to the wall, he didn't fold. His perception of the situation was clear. He knew there was nothing he could do to change the circumstances or fight his way out; no amount of his own courage or creativity would rescue him from his dilemma. What was his perspective? "We don't know what to do, but we place all our trust in God."

Instead of focusing on the magnitude of his frustration, he focused on the magnificence of his God! Most of us rivet our attention and energy on our frustrations. We analyze, worry, and become aggravated, and before long, we find ourselves dominated by our frustrations. Sleepless nights and unproductive days follow one after the other. Even in our dreams, frustration confronts us. Finally, we reach the conclusion that since the frustration is bigger than we are, there's no way out from a life at ground zero.

Dad had concluded that the frustrations he faced were bigger than he was, that there was no chance his small congregation could defeat the combined forces of evil. He wasn't naïve, but he didn't close his eyes and hope the problem would go away. Instead, he opened his eyes and saw the wider picture. He saw that behind his big problem was a bigger God! My father had learned that God is bigger than any circumstances, that He isn't limited by our inabilities

or bewildered by our confusing situations. "We don't know what to do, but we place all our trust in God."

The reason some people become debilitated by certain events while others overcome them is because their perspectives on the events differ. When people are fired from their jobs, some could take the perspective that it had happened because they were terrible at their jobs and become depressed, while others in the same situation see it a different way: they feel that as unfortunate as the firing was, they were going to keep a positive perspective and immediately start looking for another job; they realize they may have certain deficiencies or shortcomings, but that doesn't mean they are worthless. Those who give into despair take on negative, self-defeating attitudes that keep them at ground zero, while their more-hopeful counterparts learn to look at their being fired as learning and growing experiences.

No matter what our situations are, no matter how big our problems may seem or actually be, as God's people, we shouldn't let ourselves be blinded from seeing how great our God is. We need to keep our frustrations in perspective and see them as God sees them—as difficult but never impossible.

Chapter 4

Pastoring a Church at Ground Zero

Evidence abounds throughout history that people don't come together unless they're called. It may be a church bell or drum that calls them, or it could be a spoken or written message. It could even be the result of a mother's calling her family to dinner. Barring such reasons, people generally don't congregate unless there's a reason. The message of the Bible is the call of God to men and women through the years—to Abraham to leave his country, to Moses to rescue the Jews, and to prophets and prophetesses to move from ground zero to discover and live out their true callings.

The Bible has been God's call to men and women for thousands of years; it is a call that always summons us to move up from ground zero. However, it is also the sad story of human's refusal to that call. The church bell may ring, but we may not answer it. The mother may call her family to dinner, but the children may be too busy to hear. Like the prophets and patriarchs, I also felt the calling of God on my life but wasn't sure why the Lord was calling and what He wanted me to do in His kingdom.

I grew up in a Christian home; my father was a pastor and my mother a faithful, dedicated servant of God. The Word of God was always a part of our family. Because I lived in a godly household, my heart was already seasoned and prepared with the Word, so it wasn't

much of a problem when I surrendered my life to preaching God's Word at the tender age of twelve.

Nevertheless, this new life I embraced had its challenges, one of which was determining why God was calling me and what He wanted me to do. This took me a long time to figure out, but it later unfolded because of the different areas of ministry I became involved in at church. Some of these included being a Sunday school teacher, youth and men's league president, church secretary, and a local preacher. Because of my involvement with the church, my pastor, family members, and friends encouraged me to think about the pastorate. At first, I declined because of the many difficulties I saw my pastor undergoing. He was always on the move—conducting meetings, funerals, and weddings and visiting the sick at home and at hospitals and visiting those downtrodden by society and in prison. He was also doing all this for a very meager stipend.

Another reason why I wasn't so keen about the pastorate was because my initial aim was to become a lawyer. In addition, I had two physical impediments, asthma and a severe stuttering problem. People in my school and community used to refer to me as "Dummy." I was very reluctant to become a pastor because I always held that a minister should be able to clearly communicate God's Word and be in good health.

After high school, I went to college with the intention of pursuing a law career, but a few years into my studies I switched to anthropology and secondary education. The switch was the best decision the Lord has allowed me to make. The A minuses and the B pluses I usually received were replaced with straight A's. I found my greatest strengths in the study of anthropology and secondary education, and the switch allowed me to graduate with departmental and other honors.

Because of my academic success, I was convinced I was going to do graduate work in my fields. I did, and the results were great. I enjoyed the thought of becoming an anthropologist, but I also relished teaching, and I could not see myself doing anything but teach. I turned out to be wrong; God wanted me to try again doing something I had ruled out—going into ministry.

Although I enjoyed teaching, there was an even greater love in my heart for the study of God's Word. I was preoccupied daily with thoughts of going into ministry, but I would dismiss these thoughts by saying I would consider ministry sometime later in life. God's call, however, became so urgent that I had no choice other than to say, "Lord, here I am. Send me." I went to seminary.

While in seminary, I could not explain how I got there after such reticence. Later, I was able to use the biblical call narrative, Isaiah 6:8, to describe my call to move out of the comfort zone of ground zero. Two great truths in the call of Isaiah have guided me through my Christian walk of faith. There is, first of all, the fact that God is sovereign. "Whom shall I send?" sets forth the proposition that God is in control. He is God, and He sends His servants into His vineyard to serve as He sees fit.

Second, humans must be willing to serve the living God. The heart of human beings must respond to the divine query. Isaiah had no problem with God's sovereignty, and he readily offered himself to the Almighty to use as He saw fit. The words of the prophet from Isaiah 6:8, "Here am I; send me," have been my response to God's call. Sometimes, we worry and become unwilling to give up our plans to allow God to work through us, but if we have so desired and have resolved to come to God, we must make a distinction between our private ambitions and devotion to God. By answering the call of God, my asthma and stuttering are now impediments in my past. In fact, my impediments validated my call to ministry in the sense

that God removed these things from my life to allow me to carry out His will in the most efficient manner.

Ten years ago, I was called to be the senior pastor of the New Birth Pentecostal Church of God in the Bronx, NY, where my father had been the pastor for twenty-two years. Unlike many established churches at the time with elaborate buildings, huge property, large membership, and plenty of money to fund outreach programs, New Birth Pentecostal was at ground zero. During my tenure as pastor, the church faced several challenges, two of which are still fresh in my mind.

The church's first challenge was a court order that came from the New York City Department of Housing forcing the church to vacate its building; in the department's judgment, it was unsafe because of numerous building violations; correcting those violations would have cost thousands. New Birth Pentecostal became a church without a permanent home, and this was a very difficult time for us as a congregation. We had to shuffle between various sites, and our attendance dropped.

The second dilemma facing the church was a plot to overthrow me as the pastor. Things did not go as planned for those who wanted to get rid of me, so that resulted into a split, during which about sixty people left to start another church. The compounded problems left a further financial strain on the church, which resulted in the sale of the church's building and a piece of property.

Members of the church held services in their homes; we shared space with other ministries and rented other facilities to keep the church family together as best we could. With the absence of a permanent church home and the effects of the church split, attendance dropped from 105 active congregants to as low as 7 any one Sunday.

This ground zero tragedy did not get me discouraged. I didn't bother to rivet my attention and energy on the congregants and

property we had lost. While I felt saddened by the low attendance and our inability to provide the services we wanted to the community, these difficulties helped shape my view of ministry.

As the years passed, God opened new doors of ministry for our church. Today, the New Birth Pentecostal Church consists of other churches in the United States and the Caribbean. True to its mission, the church has been a leader in integrating God's Word into every aspect of its teaching and practice, thereby becoming partners with other human beings in all parts of the world; we provide for those who are displace, diseased, distressed, bruised, rejected, and suffering. In 2012, the church launched its first foreign missionary outreach when we sent a minister into the inner city of Kingston, Jamaica, to work with at-risk children and families.

The mission statement of the New Birth Pentecostal Church emphasizes social mission as an essential area of its ministry. It states,

> New Birth Pentecostal Church is committed to the spreading of the gospel throughout the world, and to provide leadership and service to address many of the afflictions of human kind in our society. The New Birth Church aims at: Respecting all people regardless of race, creed, nationality, and socio economic status. Seeking justice and equal rights for all people; ministering to the poor by sharing with them, learning from them, and empowering them; working in collaboration with the family and community to create a better world; and providing a caring multicultural community in which all people are nurtured and encouraged to reach their full potential.

This pronouncement of social mission is at the center of the New Birth Pentecostal Church. It is in the church's book of discipline, which states that New Birth Pentecostal is the body of Christ for all true believers who are governed by the lordship of Christ and willing to become vehicles of change to help address some of the social problems plaguing humanity. As its pastor, I have no regrets I answered the call to pastor a church at ground zero because it is today an agent of change in society.

Chapter 5

The Other Side of Ground Zero

Most of us don't need to go back very far to recall the last time we felt failures and sensed we were at our own ground zeros. Examples come quickly to mind.

- A teacher who has put hours and hours into preparing for a major exam to acquire an important license only to find out that each time, he or she fell short by a few points.
- A would-be driver who did everything well the day before the actual road test but during the test failed parallel parking, botched U-turns, failed to stop at stop signs, or forgot to signal before a turn and failed.
- A parent who has spent a great deal to send a child to a private school in hopes of seeing that child go to college but instead learns that the child is running with the wrong crowd and was arrested or even shot.
- A loving husband discovers his wife's long-lasting infidelity with a best friend.
- A bride-to-be who discovers that her fiancé has recently fathered another woman's child.
- A hard-working immigrant whose visa has expired and is faced with deportation even though he has worked hard to support his family and pay his bills.

No matter what form ground zero takes, it can give us a sense of loss; it can cause major upheaval, seemingly destroy our best-laid plans, and make us more than miserable. It allows us to feel unworthy and totally unaccepted by society. Life at ground zero can cause us incredible, heart-felt pain that saps our energy, joy, enthusiasm, and enjoyment of life.

According to the world's standard, a life at ground zero is a failure. *Zero* is a term, a concept in all people's vocabularies and familiar to everybody the world over. Although I know the genesis of life at its lowest, which came to fruition with Adam and Eve, at times I think about the many zero streets and boulevards I have trod in my four decades of life. Those times, those walks, however, have drawn me only closer to God.

A life at ground zero can often deceive God's people and keep them from trusting God to lead their lives. Sometimes, these zero times will cause us to feel alienated from everyone and everything and simultaneously keep us from recognizing the reasons why we fell short. Another result of living at ground zero is the sense of weakness; the many zeros in our lives simply drain our energies. It can cause even the strongest people to die spiritually and psychologically if not physically. Whenever things cease to operate as we want them to, it doesn't necessarily mean we fail. It could mean God is calling us to trust Him more.

Despite a life at ground zero that could cause many of us to run into hiding, we should not allow that to happen as long as God sits on the throne in heaven. Simply being alive means we are not failures, and if we have life, we have hope. Job validated this.

> For there is hope of a tree, if it be cut down, that it
> will sprout again, and that the tender branch thereof
> will not cease. Though the root thereof wax old in

the earth, and the stock thereof die in the ground;
yet through the scent of water it will bud, and bring
forth boughs like a plant. (Job 14:7–9)

It is not God's will that we end up negligent in our duties when
we fall short of our expectations. It doesn't matter how many times
we have failed in this life. As did Job, I believe there is hope and
good reason to try again. Some of us are like the tree Job referred
to. Think about it; a tree provides a habitat for wildlife and shelter
from the sun for us. Certain trees provide us with the raw materials
for furniture, paper, food, and even perfume. Though trees are a
special mark of God's creation, humans are far more important; they
were created in God's image. Humans have a purpose and a duty
to perform each day of their lives. We understand why some people
advocate against deforestation—trees are important—but trees will
always be cut down. The same is true for men and women: they will
be cut down, but they have the potential to sprout again as long as
their souls are watered with the Word of God and accept the Holy
Spirit to dwell in them.

Why should we ever give up on ourselves when God has not?
We can be that tree of life! God is counting on us to provide shelter
and comfort to others. We may think all is lost, but our trees say
otherwise. Our roots run deep, and all we need to do is expose
ourselves to water and sunlight—the Word and Spirit of God.

We desire to be successful, whatever that may mean for us.
We want to achieve something in our vocations or avocations. We
want to feel confidence and acceptance based on what we do. We
desire the right balance in life. We want people to trust and have
confidence in us. No matter the ugly things people may say about
us, we know we have purposes for our lives even though at times
we are kept at bay due to lack of opportunities.

Life on the other side of ground zero is designed to keep us from finishing the race of life we are called to participate in instead of standing on the sidelines. Can we afford to allow fear to turn us into cowards by crushing our courage? Should we allow failures to keep us in bondage when Jesus has already set us free?

Life on the other side of ground zero is not a strange phenomenon. It comes to everyone at one time or another. As a person all too familiar with struggles, as a teacher who hears the pain of my students and sees it each time when a student comes to me worried about grades, and as a pastor whose goal it is to give hope and courage to those who have encountered some forms of failure, I have learned some important truths about this monster called failure.

The first human family was placed in a lovely environment, the garden of Eden. They had everything going for them. In fact, they didn't have to worry about paying rent, buying food, working, or paying taxes. All things and more were provided for them. But they lacked one thing—obedience. They did the opposite of what God had commanded them to do, and their actions had far-reaching effects until this very day. Humans became a failure.

Not every zero situation is bad; each one is designed to teach us a lesson and make us better people. No matter how many times we have failed, we still have a God who never can and never will fail. Everything in life will ultimately fail and crumble, but our God will stand sure for all eternity. He invites us all to trust Him and take Him at His Word.

The zero side of life is a personal thing we can look at in many ways. We need not worry about others who would like to see us fail. Sometimes, what we call a zero is what God calls an opportunity for success, because He is the one who opens doors and avenues. He did that for Sarah when she thought she couldn't bear a child after menopause; God thought otherwise.

As Christians, *failure* should never be the first word in our vocabularies. The gospel we embrace means "good news." Failure is always attached to bad news, and we will always have failure, and even the greatest of saints and superstars will have their bouts with failure of one kind or another, but the gospel should settle all our conflicts with failures.

Chapter 6

Don't Count Out Those at Ground Zero

Many people are shunned by society because they have fallen through society's cracks. They have had some bad breaks in life; you can spot them easily. When you see them on the streets, you pass them quickly without making eye contact. These are the outcasts ... the fringe crowd ... the losers ... the nobodies ... those whom others count out because of all the zeros in their lives.

Joshua 2 reminds us that our God delights in taking nobodies and making somebodies of them. He loves to do extraordinary things in the lives of ordinary people. In Joshua 2, we read about a woman who was counted out of the race of life, written off by society. She had a vocation that would disappoint most parents. God, however, had a plan for this woman's life. He was ready to give her a makeover, to recycle her by His divine grace. God had a second chance in store waiting for this woman.

The woman was Rahab, a hooker in Jericho. Joshua sent two spies to determine the strength of the city. Word of their presence reached the king of Jericho, who searched for the spies. Rahab outsmarted the king; she hid the men on her roof and sent the officers on a false chase toward the Jordan River. Before the spies left, she asked them to spare her and her family when the Israelites invaded. The two spies gave their word. They promised that if she

would gather her family and hang a scarlet cord out the window to mark her house, all would be spared.

Later, when the walls of Jericho fell, Rahab's house was not harmed. This is the story of a prostitute, but there is more to the story. Rahab became more than a prostitute. Joshua tells us Rahab married a prince of Israel; the prostitute becomes a princess. Matthew named Rahab as Boaz's mother (1:5) in his genealogy of Christ, making her one of the Lord's ancestors. The harlot becomes the great-great-grandmother of David the king.

Rahab is listed among the heroes of faith in Hebrews 11:31. A prostitute was in the lineage of our Lord. Who would have thought this nobody, whose life was at ground zero, this hooker, someone counted out of the race of life, would become somebody extraordinary?

Rahab's story reminds us that even though people may count us out because of a present situation, God, the God of grace, offers us second chances. God did not give up on Rahab; He did not write her off His plan for salvation. After all, Rahab could sing, "Amazing Grace, how sweet the sound." I can't explain why God didn't count Rahab out except that His grace is bigger than all our problems and any of our messes, our addiction to alcohol, tobacco, or porn; our marital troubles or the memories of a difficult childhood. God's grace will come looking for us even at ground zero.

As you read the story, you discover that Rahab did not seek God—God sought her. It was God who had sent the spies to her, and when they encountered Rahab, they discovered she already believed, so they didn't have to convince, convict, or persuade her. Rahab, the prostitute of Jericho, a harlot and a pagan, had already come to believe there was only one true God.

We should never count the Rahabs out in life because God's grace accepts us all as we are. Grace says, "Come as you are," and

God's grace changed Rahab; she was converted and transformed by the power of Almighty God. Rahab's new lifestyle meant that her wardrobe had to be radically changed along with the places she went, the things she said, and the people with whom she consorted.

Rahab's heart was changed—she could no longer be a prostitute. The Bible said, "For if any man be in Christ, he or she is a new creation—the old is past and the new has come" 2 Cor. 5:17. Rahab could sing, "What a wonderful change in my life has been wrought, since Jesus came into my heart! Don't count me out!'

In the public's eye, I may score low in the polls as a preacher, but it is not for others to count me out; the votes are still coming in. You better wait to hear who the winner is. Most times, the real winners are not announced at first. Their names are not always on top, but God has a way of reminding the faithful we are still in the race—so don't count me out. I may be at the back, but God has his way of bringing us to the front.

Don't count me out! Sometimes, even parents count out their children and teachers count out their students. Many times, preachers count out the very people for whom God shed His precious blood. Like Rahab, David, one of the kings of Israel, was counted out and written off by his own father, but when "Your mothers and fathers forsake you" Ps. 27:10, the Bible said God will remember your name because He has a plan for your life. Even when every name has been called except yours, God will send them to where you are. That was what happened with David; Jesse had seven sons, and he called every name except David's. God knows our names and knows where we are. If it means He has to send someone to get any one of us, He will. Although Jesse didn't remember David's name, God looks not on outward appearances as humans do but at the heart.

God wanted David to be anointed, and nobody could stop that from happening. That was why they had to send for him in the field

to be made king of Israel. God is preparing us for greatness. Don't worry about those who are writing you off; their pens will soon run out of ink, but God's pen puts permanent marks in the Lamb's Book of Life that no devil's eraser can get rid of; God signs His book with the precious blood of Jesus.

I encourage everyone to stay in the race, keep on running for Jesus, be persistent, and resist the Devil because he will flee from you. "The race is not for the swift, or the battle for the strong, but to those who endured to the end" Ecc. 9:11. Pray for endurance. Don't count me out! God refused to give up on Rahab, he refuses to give upon us.

Don't count me out! Had I said twenty years ago that I would attend college and earn five degrees, write a book, teach at the City University of New York, write a grant to study in Egypt, and preach to more than 10,000 people in 2002 at the Fijian Methodist Conference, many—including one particular English teacher who embarrassed me in class—would be surprised. I had walked five miles one day to get to school, and I hadn't had breakfast. I was preoccupied with my mother's health; she had been very ill the night before. My teacher did not ask why my performance was not up to her standards; all she did was made me feel small in front of my classmates by telling me that I would never amount to anything, that I was destined to become a bum.

Look what she did for me—she made me better, not bitter. Her negative remarks were designed to plant a bad seed in my heart, but I rose above her criticisms and became a better teacher. Unlike my teacher, I choose to do my best to help my students. I ask about their behavior rather than making "ground zero" decisions about them.

We must not give up on people. Some just want a start. Their gifts are already in place, but sometimes those gifts, their potentials, need to be nourished and encouraged. God specializes in putting

back the pieces of our lives together. He can do the same for any one of us as He did for Rahab.

The harlot who became the great-great-grandmother of King David laid a good foundation for King David, who had his own experience at ground zero. In 1 Samuel 22:1–2, we read,

> David therefore departed thence, and escaped to the cave Adullam: and when his brethren and all his father's house heard it, they went down thither to him. And every one that was in distress, and every one that was in debt, and every one that was discontented, gathered themselves unto him; and he became captain over them: and there were about four hundred men.

In this story, we encounter a David overwhelmed by life and in a dark, damp, dreary, depressing cave. He had experienced the loss of everything and could not find anyone to lean on. David was alone, defeated, and discouraged.

Psalm 61:1–2, written around the time of our story, offers us David's desperate cry of help to God: "Hear my cry, O God; attend unto my prayer. From the end of the earth will I cry unto thee, when my heart is overwhelmed: lead me to the rock that is higher than I." The cave presented David with sorrow; it meant David was forced to give up the comfort of his own bed. Instead of a pillow, he had a stone. In this hour of loneliness, hardship, and desertion, David came to value suffering. God had not put David into this situation because God was bad but because He had to do it so David could fully depend on Him and not on his friends, family, money, fame, or flesh. God brought David to the cave to discipline and empty

him, to develop him into the man He wanted David to become in the near future.

In the cave, David was cut off from his family, friends, and followers, but God was only setting him up for a blessing. Many of God's servants have had such "cave" experiences.

- Jacob was alone in his tent.
- Elijah was alone by the brook.
- Job was alone surrounded by his friends.
- Moses was alone on the backside of the mountain.
- Jesus was alone in the garden of Gethsemane.

Each of these experiences of being shut off by the Lord, however, resulted in great triumphs. Many people don't like cave life, but it can offer instruction and growth. Those who will be used mightily by God, as were David, Jacob, Elijah, Job, Paul, and Moses, must go through their cave experiences and pass their tests.

When David thought all was lost, we are told people began to show up at the cave. His family came, then the defeated and downtrodden men of Israel began to show up. David's family came out of fear of Saul and the rest came because they believed God had called David to lead Israel. David rose to the challenge; he did not allow cave life to break him. It was hard living for David, and he knew he could not stay there forever, but he had to stay there to see what God had in store for him. While in the cave, David's family, the very folks who used to doubt him, paid him a visit. His father had ignored him, and his oldest brother had rebuked and criticized him, but they began to see he was God's choice for king. It takes the cave for some people to see we have potential and that the call of God is upon our lives.

The letter *D* is a good way of remembering those who came to visit David. First came the distressed, those who were under pressure and stress. Those who were in debt came. As well, the discontented also came; these were bitter people who had suffered mistreatment under the oppression and taxation of Saul and believed David was God's man for Israel.

God was orchestrating a plan to transform David into a great king. God took what seems to the world, a bunch of good-for-nothings, those who were distressed, in debt, and discontented, and made them good for something. After these men came to David, he was able to take his mind off his problems and focus his attention on training them to be a fighting force. In 2 Samuel 23, these ragamuffins became "mighty men."

God brought David into a cave with enemies after him. We have no doubts that David suffered. We read how he was squeezed by Saul and others who wanted to abort his dream. Many of his enemies tried to squeeze David, but he didn't get sour. Instead of bitter lime juice, he came out as refreshing limeade.

What comes out of you when people squeeze you? Do you get bitter and sour when trouble comes, or do you still praise the Lord? The tables were about to be turned. The time came for David to climb out of his cave, and it didn't matter how many *D*'s were coming at him, whether demons, disasters, destruction, diseases, disappointments, doubts, darkness, dungeons, deserts, or death, but he was going to squeeze his way out of that cave. To those who have been in caves for many weeks, months, and even years, I say you were put there for a reason.

Chapter 7

The Long Years at Ground Zero Are Almost Over

The long years of ground zero are for our healing. John shed some light on this thought in John 5:5–9, in which he writes about Jesus being in Jerusalem for a Jewish festival. Jesus showed up at a swimming pool in the shape of a pentagon with five covered porches where people could be protected from the weather. Why five? Five is the number for grace. A multitude of people who were blind, lame, and paralyzed were at the pool at Bethesda. Their bodies were twisted and sick. They were useless and dependent on other people for survival. One person at the pool had been sick for thirty-eight years; he had lived half his life in suffering and pain. Three is the number for God and eight is the number for a new beginning. The man had been sick longer than Jesus had been on earth, but he was about to experience a new beginning.

The man was disabled; he could not walk, and he had been in a sitting position for thirty-eight years. He had to be carried everywhere he went, and he was forced to beg. The man was also desperate; he was at the pool because he wanted to be healed.

John tells us that at a certain season, an angel would descend into the pool and stir up the water, but this disabled man could never get to the pool; by the time he would drag his body across the porch to

get into the pool, he would have lost his opportunity. He must have seen others get into the pool ahead of himself time and time again, but he couldn't. His dreams were shattered. He wanted to make a move, but he could not because of his condition.

He was surrounded by people also disabled one way or another; they could offer him no comfort or help. He was crippled to such an extent that he could not even carry his own bed. Jesus knew he was totally dependent on others for everything, yet Jesus reached out to him. It was not by accident that Jesus was passing his way; Jesus had been paying attention; He knew thirty-eight years was a long time, but He also knew the disabled man's hour had come.

Your hour may have come today; Jesus will show up just because of you today, and with that comes the guarantee that your condition will change.

In essence, Jesus asked this sick man, "Do you want to be made well?" The sick man answered, "Sir, I have no one to put me in the pool when the water is stirred up; and while I am making my way, someone else steps down ahead of me." The man's focus was the pool. Jesus had come, but the disabled man did not recognize him; all he saw was a pool he wanted to get into but could not. What's your pool? God is bigger than it no matter how big it is.

In verse 8, Jesus gave the sick man a command. "Get up! Pick up your mat and walk." Jesus told the sick man to do something he had not been able to do for those thirty-eight years. Nobody could get up for him; he had to do that himself. I can't walk for you; I don't control your feet. If Jesus asked you today to do something you've never done before, what would your answer be? If Jesus asked you if you wanted your own home, would you answer Him as the sick man did? Would you tell Him your credit was bad and you were broke? That's not what He asked; He asked, "Do you want it?" Yes or no.

You might be in a condition similar to that of the disabled man, but the good news is that Jesus is passing your way today with an offer. Will you follow Jesus' order, get up, and walk? Many today are in such crippling conditions that they can't do what they want; some have been in that condition for years with feelings of helplessness and bitterness. Some have immigration problems, others have desires they just can't seem to fulfill, but I assure you the Lord is going to make a way for you. Yes, it may be a long time coming, but you should not mind waiting on the Lord because He is going to come true for you. God is going to make a way for you. You are next in line for His blessings and miracles. God is getting ready to take you out of your condition, so stop worrying! Jesus is at your pool.

Acts 3:1–2 and 4:22 tells the story of a sick man who had an even longer wait at ground zero. Peter and John, two of Jesus' disciples, were on their way to the temple when they encountered an unnamed beggar who had been born lame, and according to Luke, he was over forty. He had nothing to boast about; he simply begged every day in front of a beautiful and famous gate that represented the religious structure of the day. It is said that the gate was made of Corinthian brass, and it was worth probably scores of thousands of dollars. Most who came by admired the gate, not those who were begging near it.

In the midst of this crippled person's forty-year battle with his condition and always having to be dependent on other people, God sent two disciples. Peter and John saw a man who had been passed by for weeks, months, even years by leaders, rabbis, and preachers, but nothing had changed his condition. Here was a man with the same worry, the same cry, but he had been kept outside because of his disability, which rendered him unfit to enter the temple.

Many people in the world are like this lame man; they find themselves in the same situation for years and years. Like the lame

man, these people's names never get mentioned; people know them only because of their conditions in life—that deaf man, this blind lady, and so on. Those who passed by our lame man didn't care why he was lame or how long he had been that way; they didn't have a problem seeing him down. We, however, need to lift up each other if we are strong. This was exactly what Peter and John did.

The lame man looked at Peter and John and said, "Give me alms." This man had an imaginary and a real need. His imaginary need was that he needed money; his real need was that he needed God, the one thing money could not buy. Peter and John did not have any money, but they had something money could not buy—the anointing of God on their lives. Peter said, "Silver and gold have I none; but such as I have give I thee: In the name of Jesus Christ of Nazareth rise up and walk." Up he went. Miracles took place, prayers were answered. Something happened, something unusual, something extraordinary.

In Act 3:7, Peter took the man by the right hand and lifted him up, and according to Luke, "immediately his feet and ankle bones received strength." The story becomes more interesting in verse 8: "And the lame man leaping up stood, and walked, and entered with them into the temple, walking, and leaping and praising God." His long years at ground zero were almost over; the same temple that had denied him entry was now open to him. Likewise, that same job you sought, that same school that denied enrolling you—they will be open to you. (This only goes to remind us that when we enter church, it should be to praise God.) The man could walk, the generational curse had been destroyed, and doors once shut to him opened.

Forty years of agony, frustration, and despair were the experience of this man, but God send somebody to let him walk for the first

time. Those of you who are sick will regain your health, and those of you who are unemployed will find work, and those of you who are dependent on others will gain independence when the Word of God comes today; your ground zero days will be over.

Chapter 8

Just Empty Jars

Something about emptiness makes it very embarrassing, and we see evidence of that in John 2:1–7. This passage records Jesus' first miracle; it took place at the wedding in Cana. Mary, Jesus' mother, was invited, as were Jesus and His disciples. We are not told who was getting married, but it was probably some close kinsman to Jesus, perhaps a brother, a sister, or a cousin. I say that because Mary was involved in the festivities. We have seen from John's account that Jesus' presence and participation at this wedding reminds us He cares about our everyday social life and isn't just for Sundays!

Weddings were and are a big deal in the Jewish culture, and a certain protocol was to be followed. If the bride was a virgin, the wedding occurred on Wednesday. If the bride was a widow, the wedding came on Thursday. Wedding ceremonies took place late in the evening after a time of feasting. The father of the bride would take his daughter on his arm and with the wedding party in tow would parade through the streets of the village so everyone could congratulate the bride.

The wedding took place in the front door of the groom's house. It was no short ceremony; the festivities lasted for days. It was a time of great celebration. After the wedding ceremony, the bride and groom walked through the streets accompanied by flaming torches. Their attendants walked with them, keeping a canopy over their

heads. The wedding party always took the longest route through the village so as many people as possible could wish them well.

There was no such thing as a honeymoon! The couple kept open house for a week. They were treated like royalty. They dressed in fancy clothes and many times wore crowns. Whatever they wanted they received; their word was law! The groom's family was expected to provide all the refreshments for this week of festivities.

The host at this wedding discovered a crisis; a big problem arose. They had more guests than they had anticipated and had run out of wine—most improper! Evidently, they did not have the money to purchase more. What do you do when you run out of wine and can't buy more? What do you do in the face of embarrassment? The Bible tells us Mary told Jesus about the problem and asked for His help. Jesus' mother told the servants, "Do whatsoever He tells you to do."

We live in a world where Mary's statement would not fit well with a lot of people. "Do whatever he tells you." The servants didn't have to listen to or do what they were told because in reality, they have never seen Jesus perform a miracle. This was Jesus' first miracle; obedience to the voice of God will take us out of any embarrassing situation. It doesn't matter what is running out in your life—just do what the Lord tells you to do. To the Jewish people, wine symbolized joy. The rabbis had a saying, 'Without wine there is no joy." And at the wedding in Cana their joy had run out! It is a reminder of the emptiness of our lives without Christ. There are times when the wine runs out and the joy dries up, but we must believe the best wine will be served at the end.

Jesus has strange ways of getting things done. He performed the miracle with the help of some pots of water with which guests washed their hands; it was considered a defilement to eat with unwashed hands. Jesus can take hand-washing water and turn it into whatever He pleases. Jesus is getting ready to perform a miracle in

your life, but you must stop focusing on the water pots. You must stop worrying about what is running out. You must instead look to the one who can turn your embarrassment into something else. Jesus is about transformation. He turned

- water into wine;
- frowns into smiles;
- whimpers of fear into songs of hope;
- deserts into gardens;
- sorrow into joy;
- sin into grace;
- night into day; and
- death into life.

In verse 7, Jesus gave His first command: "Fill the water pots with water." Each pot could hold about thirty gallons. The servants filled the six pots to the brim. I want run-over blessings in my life this year; I too want to be filled to the brim. But even when it seems I'm running the race on empty, oh how I want to live out the words of the apostle Paul in 1 Thessalonians 5:18: "In everything give thanks: for this is the will of God in Christ Jesus concerning you." Two words in this verse are designed specifically for a life at ground zero: "in everything." We are called to give thanks to the Lord not *for* everything but *in* everything, a big difference! We ought to be thankful not just because we are told to be thankful but because we have much to be thankful for!

We should be thankful for everything, not just physical things. We are thankful for our health, our families, our homes, and our jobs, but health can break, families can split up, and bank accounts can run dry. What do we do then? How does that affect our thankfulness?

Life at ground zero is our best time to thank God for His presence. Regardless of where the path of life leads, we should be sure the people of God will never walk alone. We have someone to run to, someone to who will help us, fight for us, and comfort us. One of our greatest sources of thanksgiving in my life is the truth that Jesus never changes. What He was then is what He is now! From before creation or into eternity, Jesus has never, nor will He ever, change! He is still the great I am. He still possesses all power in heaven and in earth.

I thank God for my salvation and the price He paid for it. We must give thanks to God in everything because He sent His Son to earth. Jesus sought you. He called you. He died for you. He redeemed you. He keeps you. He satisfies your needs. In everything, I thank the Lord for changing me. When our jars are empty, we should still thank the Lord. The gospel of John calls us to be joyful when we see miracles and thank God in the midst of what seems to be an embarrassment.

John 6 presents another embarrassing moment for a people at their ground zeros. A multitude, 5,000, had listened to Jesus preach and were hungry. In verse 5, Jesus tested the faith of Philip by asking him where they were going to get bread to feed all those people. Jesus had the answer; indeed, He was the answer, but He wanted to see how Philip would handle a crisis.

Instead of responding in faith, Philip responded in unbelief. He said it would have taken the average worker eight months to earn $10,000 in today's money to feed so many people. The focus shifted from Philip to Andrew, but Andrew's faith was just as shaky as Philip's. Andrew found a boy who had five barley loaves and two fish. Andrew said that one boy's lunch would not feed 5,000 people, but he was smart enough to put what was not enough in the hands of the Lord.

The number five represent recompense or bounteous reward; it also represents God's grace seen throughout the structure of the tabernacle in the wilderness. Five is also a number of preparation. The number two in the Bible denotes a difference, a division, or a separation. Two is the minimum number for witnesses. "By the mouth of two or three witnesses the matter shall be established" (Deuteronomy 19:15).

The bread and the fish were in Jesus' hands. Before Jesus performed the miracle, He told his disciples to let the people sit because He was a God of order. "And when he had taken the five loaves and the two fishes, he looked up to heaven, and blessed, and broke the loaves; and gave them to his disciples to set before them; and the two fishes divided He among them all" John 6:11.

What is the message here? You can't hold on to what you have and expect a blessing. You can't hold on to your fish and bread and expect a miracle. You need to release whatever is in your hands and place them in God's hands. Jesus took what was not enough and blessed it. How many of you can bless what is not enough without complaining?

The Bible tells us that Jesus took the five loaves and the two fish, lifted His face toward heaven, and blessed the food. Jesus was not worried about the small amount of food; He took what had been given to Him, blessed it, and began to break it and hand it out. Jesus took what was not enough and multiplied it. Matthew 14:21 tells us that 5,000 men plus women and children were fed, which could have been as many as 20,000 total.

God wants us to use what we have to be a blessing to others. The little boy was not selfish; he shared his lunch. The Bible tells us that after everyone was satisfied, there was a surplus, a multiplication. When your meager gifts are in the hands of a big God, there will be leftovers. Jesus can take your little and turn it into a lot. Place

your little in the Lord's hands and He will multiply it. God is still able to stretch your little paycheck because you brought it into His hands. God didn't expect that little boy to have enough to feed 5,000; He expected the boy only to place it in His hands and leave the rest up to Him.

Leave your gifts and talents in the hands of God. Expect something wonderful—expect something incredible to happen today because you have placed your life in the hands of the Lord. After everyone was fed, Jesus gathered the leftovers so nothing would be wasted but be used to bless someone else. God wants us to be a blessing to others and His church. Our job is not to worry about the amount because little is still much when God is in it.

We serve a God who is more than sufficient to save and forgive us. He can take your little and give you a miracle by stretching it so much that it will meet all your needs.

Chapter 9

A Time and Place for That Zero

To everything there is a season, a time for every
purpose under heaven:
A time to be born; And a time to die; A time to
plant, And a time to pluck what is planted;

And a time to kill, And a time to heal; A time to
break down, And a time to build up;
A time to weep, And a time to laugh; A time to
mourn, And a time to dance;

A time to cast away stones, And a time to gather
stones; A time to embrace,
And a time to refrain from embracing; A time to
gain, And a time to lose; A time to keep,

And a time to throw away; A time to tear, And a
time to sew; A time to keep silence, And a time to
speak; A time to love, And a time to hate; A time
of war, And a time of peace.

——Ecclesiastes 3:1–8

The time to get serious about our relationships with God is now. We naturally think of the passage of time in many ways. Some of us depend on calendars, while others depend on clocks. Some think sadly about their advancing age when they remember their youth. The most profitable way we may think of the passage of time is to say to ourselves, "I know I've wasted many precious years, but today will be the best day of my life." Many of us have grown in age and in experience but not in Christian grace. Now is the time to ask ourselves if we are better Christians, if our praying is on a deeper level, if we are living more-Christlike lives, and if our knowledge of God is clearer than it was at this time last year.

The answer ought to be that we have advanced, for the Christian life can never be static. But if we feel we have not used our time wisely, perhaps even gone backward, we need to have a better focus of time. Time is precious; there is no time as important as today. In spite of the wars, turmoil, famine, and the AIDS epidemic that threatens the lives of many, we still have a chance to make a difference.

In each of us is a desire to spend time wisely. We don't want to spend each day worrying about what's going to happen tomorrow and whether we will be able to adapt to its changes. We want to be at peace with the present. We want to feel confident, secure, and hopeful when we face the challenges of each new day. Many of us look at time in terms of past and future. However, time is more about the present; today is all we have. Tomorrow is not certain; the future is unknown, so we should not be anxious about tomorrow: "Take therefore no thought for the morrow: for tomorrow shall take thought for the things of itself. Sufficient unto the day is the evil thereof" (Matthew 6:34).

Today is important because it could be our last. The most common way to approach today is to thank God for it. While some

people have to worry about what tomorrow will be like or about whether they'll ever get married, lose their eyesight, hearing, or memory, we don't have to worry about such things today.

One of the most frightening things about the future for some people is death, but since we are alive, we need to be thankful for today and do our best to live lives that honor God. It really doesn't matter how many times we have failed; today doesn't have to be the same. It doesn't have to be as frightening as it was yesterday. Abraham reminded us that today is the day to serve God in Hebrews 11:8: "By faith Abraham, when he was called, obeyed by going out to a place which he was to receive for an inheritance; and he went out, not knowing where he was going." Abraham had no idea what the future held for him when God called him to leave his home and venture into an unknown land. However, he didn't tell God to wait for tomorrow to do what he was asked to do that day; instead, he acted right away as God had commanded. For Abraham, as for many of us, the choices we make today can determine our tomorrow.

Some people find themselves so worried about the future that they forget that today comes before tomorrow. We should not dwell heavily on things we have not accomplished or experienced. Today confronts us with two choices: will we retreat or engage?

Sometimes we are so obsessed by past failures. We cannot forget the business setbacks we suffered, the broken relationships, or times when we failed an exam. The humiliation of delivering a speech to a huge audience poorly is stuck in our memories. Every time we think of failure, the hurt and anguish well up inside and we vow never again to put ourselves in situations in which we might have our failures publicly displayed.

Now is not the time to retreat. We cannot sit back and worry or wallow in self-pity because we have God's work to do. We want

to experience God's best for our lives. We must allow God's Word to take care of our past.

Everyone has failed at some time; many people have failed so often they've become quite proficient at it. Still, these people choose engagement over retreat. Consider this example:

> A young man ran for the legislature in Illinois, and was badly swamped. He next entered business, failed, and spent 17 years of his life paying up the debts of a worthless partner.
>
> He was in love with a beautiful woman to whom he became engaged; then she died.
>
> Reentering politics, he ran for Congress, and was badly defeated.
>
> He then tried to get an appointment to the United States Senate, and was badly defeated.
>
> Two years later he was again defeated.
>
> (Quoted by George Bowman in How to succeed with Your Money, Moody Press, p. 145).

If ever a man had a reason to retreat into the past and quit trying, it was this man. But Abraham Lincoln wouldn't quit. He wouldn't let his past failures prevent him from trying again. He placed aside the chains of the past and became the sixteenth president of the United States.

While some people prefer to retreat, all good soldiers know that retreat doesn't add up to victory. Failures of the past are designed to make us participants in the race of life. To win a race, we must be in it. We cannot drop out and expect trophies at the end; it doesn't work that way.

Engagement calls us to go forward. As much as we might feel discouraged and frustrated about things that have gone wrong in our lives, God still beckons us as He beckoned Abraham, calling us to pack up our tents and go forward to possess a land we've never seen.

Perhaps this last year hasn't been especially successful. Maybe you lost a job you poured your life into. Perhaps your friends of many years have deserted you. These events can make us feel disappointed or discontented, but it is important we continue to aim high. It is normal for us to dream big dreams, to make great plans, and to set ambitious goals.

God wants us to be the best we can be. We no longer can hide our heads in the sand because of a few mistakes we've made. The Bible is full of men and women who did not allow their failures and shortcomings to hinder the blessings of God in their lives. For Abraham, Moses, David, Isaiah, Paul, and all the other great heroes of the Bible, each day was one of great accomplishments. Although they had their trials and temptations, they didn't allow them to prevent them from achieving greatness. These people changed the world because they were willing to discover the wisdom and knowledge of God.

If we're going to accept the fact that the time to do God's work is now, we must develop a positive attitude of how we will live each day. First of all, we must approach today with faith. Like the heroes of faith in the Bible, we need faith to aim high. God knows faith is important; it's one of the things that pleases Him. God wants to lead us to the right people, to the right decisions, to the right careers, and to the right mates. However, we must have the confidence that God has the power to care for us and grant us the desires of our hearts.

None of us knows what lies ahead in our lives, what mountains we will need to cross, what rivers we'll have to wade, or what seemingly impossible situations will confront us, but that shouldn't

stop us from doing the things we are called to do to the best of our abilities. We know God will see us through every circumstance and will provide for our needs.

> But now thus saith the Lord that created thee, O Jacob, and he that formed thee, I have called thee by name; thou art mine. When thou passest through the waters, I will be with thee; and through the rivers, they shall not overflow thee: when thou walkest through the fire, thou shalt not be burned; neither shall the flame kindle upon thee. For I am the Lord your God. (Isaiah 43:1–3)

God has a strong love for us; He wants us to succeed even in the midst of our difficulties. God holds our futures in His hands, so we can approach today without fear. God has promised to open doors when we knock, and He will give us whatever we ask of Him in faith (see Matthew 7:7).

Because many of us have never dared to dream big or aim high, we become content with where we are and what we have experienced. However, we should realize God always has something more for us—more people to meet, more truth to grasp, and more experiences to own.

Now is the time to move on, to leave behind failures, fears, and memories of the past. God wants us to do something new every day and not be content with living the experiences of yesterday. Since the time is now, we can't wait for tomorrow to enjoy life. We must do it now. Whatever situation we are in, there is something to thank God for.

Don't wait until tomorrow to go back to school; do it now while you have the chance. Don't wait until you accumulate a lot of

money before you help someone in need because tomorrow is not guaranteed.

The challenge is never too great for any of God's children to take on when occasion arises. In Babylon, a difficult challenge was issued to Daniel and his friends to bow and worship the idol of the king, but they refused, which meant that they took a stand to defend the name of their God—Yahweh. And like these men, we are called on to take a stand for God, to refuse to conform to other ideologies in our society. If we believe in God, we should let it be known to the president and to the whole world. Our faith must not be shallow, the sort that thrives only when we're being protected from danger.

If you are a child of God, you should not be afraid of the fiery furnace of popular culture or being intimated by the powers that be in society. Many of us believe in God just as long as we are safe from harm—but how easily we lose our faith as soon as we encounter trouble. Most people pray only when they're in trouble, but there is no guarantee of physical safety for the person who believes in God.

Chapter 10

Dealing with the Causes
of Ground Zero

When the moral structure of a society breaks down, who in that society will rescue our people? Are there any people or institutions that have been insulted and now want to become part of the solution rather than part of the problem? Numerous studies have been conducted on the breakdown of our communities, and it is for us as a people to stop and look at our communities.

The Community of Faith

When we think of a community of faith, we should picture a place where people look after one another—a traditional neighborhood, church, voluntary association, tenant association, or demonstration demanding higher wages for those who have been exploited and marginalized.

We have failed in our understanding of the meaning of community by limiting it only to places of worship; this definition of community is narrow. The Scriptures make it clear that a community of faith goes beyond the walls of our churches. Christian communities of faith go back to Jesus (Matthew 16:18). In this community, Jesus demonstrated the joy and meaning of living for others. He lived and died for others, and He has taught us by word and example we

cannot live alone. None of us can be entirely independent of others because we are members of each other.

We, Protestant Christians, pride ourselves on the chief doctrine of salvation by faith, yet the slightest study of Dietrich Bonhoeffer's *Life Together: The Classic Exploration of Faith in Community,* shows us that the Scriptures condemn a faith that doesn't make a difference in the life of the whole community. The major theme of the book, which is worthy of special treatment, is that faith must be viewed as a community outside the church. The book typifies what a true community of believers should resemble. Bonhoeffer writes,

> Not what a man is in himself as a Christian, his spirituality and piety, constitutes the basis of our community. What determines our brotherhood is that man is by reason of Christ. Our community with one another consists solely in what Christ has done to both of us. I have community with others and I shall continue to have it only through Jesus Christ. (16)

Drawing from Bonhoeffer's argument, we can see that the beauty of our faith is that we share a common humanity regardless of the imposition of society, politics, or religious denominations. It is in this community that we share a common hope and destiny like other groups that have been oppressed and marginalized. Bonhoeffer's message is that we are all members of a larger community, the household of God, in a divided world.

The critical edge for the Christian community, according to Bonhoeffer, must find its root in the service of others. Therefore, to truly serve Christ, to be truly Christian, is to become a servant, a slave. This was what Bonhoeffer emphasized in his book. He

asked people once oppressed by Nazism to be "slaves." But to be Christ's slave, he said, was not to submit to Nazism or any form of human injustice; instead, it was to free others and ourselves from such conditions.

Bonhoeffer also argued that we can learn more about faith by our Christian "engagement." His message is that many times we confess to being Christians, we pray, attend church, give offerings, and read the words that should govern our actions, but our response is void of engagement. We like to talk about faith, but we don't like to get involved with it in our communities.

Bonhoeffer calls us to act out our faith by making a difference in the world. Our actions should not keep us aloof, and we should not allow ourselves to believe it's more important to be pious than worldly. Nevertheless, there is such a thing as worldly piety and monastic piety. Jesus was accused of being a wine-bibber! He was criticized for challenging the status quo, the establishment of His time.

We have failed as a community of faith by not imitating the same spirit of Christ to become more involved and to act more decisively in the world. Too many communities of faith are paying lip service to the call of Christ to rescue the perishing and to care for the dying. Once, when I was in seminary, a promising female minister told me she had heard I was a pastor. She wanted to know how large my congregation was. I told her my congregation was not based on numbers because I ministered not only to a church but also to the wider community. That being the case, I must have a very large congregation. Case closed.

Here was a minister in training who probably loved the Lord; she was always talking about change while at the same time she misunderstood one of the basic principles of ministry, that we are called to serve the community. At times, people will give us the impression they are more committed to their own traditions and

to their own histories as to what makes up a community of faith than they are to recognizing the fact more needs to be done in our communities of faith.

Many communities of faith are guilty of scarring the body of Christ, which becomes broken in our midst. The communities of faith to which we are called should not be based on trickery or distortion to win the approval of the masses. In contrast to imposters claiming to be in our communities of faith, we must resolve to proclaim with boldness the truth of the gospel of Christ.

No matter the response of the world and its popular opinions, the true believers who are called to the household of faith never preach their own devised gospel. In fact, "We do not preach ourselves, but Jesus Christ as Lord," Saint Paul wrote. Though Paul understood the purpose of the community of faith by becoming God's messenger, he did not exalt himself. He was a servant to those receiving the gospel. Because others have created room for projection of self in the Christian community, we have failed to create selfless servitude to God.

I believe a community of faith is based on service. And as a minister, I am called to actively serve and help others in the community. One example of where we have fallen short in our communities of faith can be better understood by considering the early Christian church. Its deacons were always helping widows and others in need. The same is true of us in the twenty-first century. Our job should be about service to our brothers and sisters, especially those who have been marginalized and rejected because of their economic status, gender, or skin color.

Conflict in the Family

Families are important, but the deprivation of today's society is reflected in the deprivation of contemporary families. Families have a God-given responsibility to lead the world in godliness; however,

they are being deprived of godliness and purity, the strength that gave birth to the family in the beginning. The family has become dysfunctional, and very little is left to be admired of the family in a world in which God's divine love has been downplayed by popular culture.

Without God's help, a cycle of dysfunction and conflict will permeate the institution of the family. The time to cry out to God is now. Families in biblical times were confronted with daily problems, but they left a great example in Psalm 107:19–20: "Then they cry unto the Lord in their trouble, and he saveth them out of their distress. He sent his word, and healed them, and delivered them from their destructions." Why did these families cry out to God? They understood the way of the Lord, and they were committed to allowing God to lead their families. Parents cannot afford to wait for the world to raise their children.

One of the duties of the family is to raise up children in the fear of God. We must teach them to pray. We must set aside quality time to listen to their concerns. Sadly, many families no longer make sure that children do their homework and go to bed early. Children are being showered with material things without being given chores that would help them develop a sense of individual responsibility.

Where are the parents? There are scarcely any role models for children in today's families. We used to live in families in which parents were knowledgeable about the Word of God and imparted its knowledge to their children and others. Many families today suffer because of divorce and separation; we need to ask for God's help to lead our households.

The family was once a great teacher. Teaching should mean applying the Word of God to our daily lives and growing in the grace and knowledge of God. We must develop good manners and a sense of our history as Christians in our children.

All families are called to tell stories, but our families have failed in that. Parents were once tellers of stories about God and our origin as a people. My parents taught me many stories. They told me about the Bible; they made sure the Word of God was taught day and night in my house. I still remember them telling us as children Bible bedtime stories. They also told us stories of our past generations; that's probably why I developed a love for history and became a historian.

Families in the past didn't have the education many families have today, but they had the fear of God, and that was enough to keep the family in check. It seems the more we go to school, the more havoc we create in the family. Here we find that while an education is essential to the family, that alone cannot stop conflicts. Many of these conflicts are created by our failures to teach our children Bible stories.

The stories that my parents used to tell us as children were simple, but they engaged me in the business of salvation and awakened my curiosity. Proverbs 22:6 tells us we must "train up a child in the way he must go … when he is old, he will not depart from it." As parents, we should use every opportunity to enforce the idea of "train up." We should also let others be aware that this idea does not denote corporal punishment but rather the dedication of the parents who want to give their children to the Lord. While parents are the biological guardians of their children, the children really belong to God. Psalm 100:3 says, "Know ye that the Lord he is God: it is he that hath made us, and not we ourselves; we are his people, and the sheep of his pasture."

Should it not be the job of all families to instruct their children to learn everything involved in pleasing God? Joshua tells us that children should be taught from an early age about the Bible and that they should be disciplined; otherwise, parents will have many

troubles trying to change or modify their behavior when they become adults. Children will get older, leave home, and start their own families, but what message or example can they take with them that they have learned from their family?

Where have we failed as a family? We have failed as a family by not wanting to take on our spiritual and physical responsibilities. I have spoken to many grandparents who were still in their thirties and forties, and they would argue they were young and wanted to live their lives but instead ended up raising their grandchildren. This leaves us to question whether these grandparents have failed their children.

We have also failed as a family due to a majority of our fathers being absent in the lives of their children. Some of these fathers spend their time on the streets drinking, gambling, and becoming the victims of violence. Some use drugs and abuse their spouses and children. Who is raising our children? Children no longer know their parents even though they may live in the same house. There is very little time for sharing, for being together, in many American families. The parents are usually running off to work and leaving the babysitter and the television to raise their children. By the time some of these parents return, they are so exhausted that they don't monitor homework, assign chores, or eat together as a family. The following are some questions every family needs to answer:

1. Is my home a respectful place?
2. How often do I pray for my children and build up their self-esteem?
3. How often do I assign my children a chore and help them accomplish it?
4. How often do my children follow my directions based on my parental example?

5. Do I spend quality time with my children?
6. Do I give my children a clear sense of their ethnic background, such as their history, traditions, and customs?
7. How often does my family go to church together?
8. Do I teach my children to respect other family members and to avoid lying, cheating, and stealing?
9. How often do I encourage my children?
10. Would I want my children to grow up adopting my lifestyle?

Home was my first school. Sometimes we are asked, "Who has been the greatest influence in your life?" Usually, we mention someone we knew—our fathers, mothers, teachers, coaches, or friends. It is often someone who had inspired us, fostered our talents and abilities, given us a set of values by which to live, or had been a role model. This used to be the way it was for the family, but something has gone wrong. Our families can provide something far better than the world has to offer—they can offer hope that can set the course of the future of other families.

The School

The children in our schools are a sober reminder of how far we have failed as a nation. While it is true we are living in a world different from that of past generations, we need to pay more attention to what's going on in one of the greatest institutions of our society, the school. It is so important for the intellectual development and nurturing of our children.

Today's schools, especially those in our cities, are confronted with many problems, and we need to come together as a society to respond positively and constructively to some of these problems. We need to take on poverty, hunger, violence, economic and social

injustice, and racial conflicts. If our business is to teach, heal, love, and liberate, we cannot sit idle.

We have schools today that are not geared toward teaching children; instead, they're just playing politics as our children suffer. We are living in an age in which education is very important. I teach in one of New York's public high schools and see the corruption that goes on every day. As a social studies teacher, I have seen the United States become a nation of preference for hundreds of thousands of newcomers. Most of these immigrants are members of my five classes; they come from almost every language and culture.

The social studies curriculum of my school is very Eurocentric, and many still regard the West as the road to a good education. Something is wrong in our schools when we promote, encourage, and teach the values and traditions of one culture as superior to another. In the interaction of everyday life between students and teachers in school, there has always been cultural misunderstanding because teachers usually do not know their students' varied cultural traditions.

The way a nation responds to its educational institutions is fundamentally a question of values. Values do not change overnight. However, we must require that social movements reshape them, and teachers, parents, and the church will be called upon to play a leading role in teaching the children of our schools that the European cultural tradition is only one of many that help shape America.

Hospitality

Most races pride themselves on being hospitable to strangers and are ashamed if members of their race show discourtesy. Travelers find hospitality even among primitive pagans. Hospitality is one of the areas in which we have failed as a people and need to ask for God's help. This humanitarian attitude is engraved in the hearts of

all people; wherever we see it, we must honor it, giving thanks to God and remembering that hospitality is not a virtue to be found only among Christians.

Long before the coming of Christ, hospitality was practiced by God's people. One example is in the story of Abraham (Genesis 18:1–16). We also find this in the New Testament with the parable of the Good Samaritan, which teaches us we need to show our neighbors we care about them despite the bitterness and confusion in our society.

Hospitality is a virtue, an integral part of the life of a civilized society. It reminds us that God treats all human beings with love and respect and intends for His people to treat others the same by showing them common courtesy.

Throughout my life, I have never seen anyone who better exemplifies this notion of hospitality than my spiritual father, the Reverend Lorima Uluiqavara. He is from the Fiji Islands in the South Pacific. He came to Jamaica as a Methodist minister, and I had my training as a minister under his humble and professional leadership.

Rev. Uluiqavara is a true example of a hospitable person. He showed me and everyone he met that we were not strangers or enemies. Hospitality for him was not mere sentimentality practiced for humanitarian motives only. Its inspiration was in the fact that he knew all people, everywhere, to be the object of God's love.

With hospitality, we can break down the partitions that separate God's people from each other. In this light, we must see the true meaning of hospitality in our treatment of other people. Some of the ways in which hospitality can be shown is by a husband opening doors for his wife and children. We are being hospitable when we give up our seats on the bus or train for a pregnant mother or an

elderly person. We can be more hospitable as drivers on the streets by giving a pedestrian or other drivers the right of way.

Hospitality can also take the form of writing letters to missionaries abroad, soldiers on the battlefield, or elderly people in a nursing home, reminding them that we are praying for them. Many times, people are not expecting us to give them material things to make them feel happy in an hostile world; all that some of these folks are asking us to do is to show we care about them and have them in our prayers.

God's intention is not for His people to be strangers at home, work, on the street, or at church. Do you remember the story in Luke 24 of the two disciples who were walking on the road to Emmaus when Jesus drew near and walked with them? They invited Him to stay the night at their house, and it was only when He broke bread that they knew He was Jesus. Is there a lesson you want to learn about hospitality? Begin by welcoming Jesus in your heart. He will come in and change your life forever.

Stewardship

Does it ever dawn on us that we have failed in becoming God's stewards? It is interesting to know that God has made us stewards of all things because of our obedience to His will. God put us in the world as stewards, someone who takes care of his master's property, his goods, his house, his land, and his money. These things do not belong to the steward but to the master. The steward must keep everything in good order and use the master's money and possessions wisely. Good stewards keep accounts to show masters all they have done. God created all things, so He is the owner of money, land, time, and talent. More important, God owns us; we belong to Him.

Faithful stewards give themselves first to God. Jesus taught that we cannot make a gift to Him or even begin to carry out a spiritual

discipline unless we are right with Him and our neighbors (Matthew 5:23–24). So when we have a right relationship with God, we must practice giving because it is a part of worship.

The Macedonians were cited as good examples of giving. In 2 Corinthians 8:5, we read, "First they gave themselves to the Lord." That's why they gave their money cheerfully. Thus, cheerful giving is possible only for people who have first given themselves to God. Paul sought after the Corinthians, not their possessions (2 Corinthians 12:14), and every church leader should direct Christians to give themselves first to God, which takes precedence over material possessions.

Chapter 11

The Church's Response to Those at the Bottom

None of us could claim to be about the Lord's work unless we were in some way helping those in need. Jesus was clear that His mission to the world was a ministry to the poor, the sick, the oppressed, and the imprisoned. As confessing Christians, we are also called to follow Christ's example and continue in obedience to do God's will. Some Christians may legitimately ask, "Suppose I'm the one who's sick, or oppressed, or incarcerated? Shouldn't I just wait to receive God's goodness? Do I have a mission?"

This brings to mind a recent trip I took to a residential treatment program to visit some former incarcerated human beings. During my visit, some women shared their experiences with me and provided me with some good suggestions about how the church can better respond to the struggles of incarcerated women in American society.

I still remember as though it were yesterday a former incarcerated young African-American woman telling me the church did not have a clue about what it means to share the good news with suffering humanity. This was an indictment of the church, and I know it has a degree of truth to it; I listened to her attentively. One very important thing that came out of our conversation had to do with the concept of *witnessing*. We both agreed that the way an individual or a church

witnesses to the gospel varies. We also agreed there were different forms of witness; there is no stereotyped witness. Thus, the form and shape of our witness, or how we live out our callings, is very often determined by the conditions of the person we are trying to witness to.

Our conversation also revealed that people have witnessed effectively by preaching and teaching. This, however, is not the only form of witness or ministry. Another way we can carry out Christian ministry is by visiting the sick, elderly, lonely, and the incarcerated. In addition, we can write letters to our community leaders or advocate with our politicians to change laws that may be unfair to some people. We can also use questionnaires to find out what are some of the basic needs of those in our communities. Also, we could hold an open forum in which we invite people from our communities to share their ideas.

The point is that we must always bear witness to God's love, to God's power to heal, to God's forgiving grace, and to God's power to make all things new. Each of us is given a different area of ministry. St. Paul made the analogy of the church as the body of Christ; each part of the body has a function, however insignificant. My calling is in teaching and mission work, and I am trying my best to be faithful in the area of ministry in which I believe God has called me to witness.

Amid the indictment of the world on the church and all the negative images it has painted, I'm still proud to be a member of the body of Christ, which has a role to play in bringing about full, systematic change to the varied concerns of people in our society. But how can we bring about change when the role of the church has been misunderstood? There are some who have come to think the mission of the church is outreach or evangelism, and of mission or programs to save souls. Unfortunately, in the United States, we

read with real concern how some churches are very concerned about people's souls yet do little or nothing to improve the physical conditions under which they work and live.

We cannot carve humans into neat compartments, a spirit here, a body there, a mind there, and a soul here, and try to save just one of these. Human beings are a totality. The Bible recognizes this, and the gospel ministers to the totality of the individual, not just its individual parts, as the church is guilty of doing. Should it not be the duty of the church to minister to the whole individual? We are called to heal the body of the sick and the mind of the disturbed. We must find time to counsel and to get involved with people in our communities.

The church must also be careful about not going to the other extreme and catering to humans' physical needs solely. Decent housing may not be the only problem people in our slums, ghettos, or those coming from prison have. They need help to create a sense of community, a sense of trust, a sense of reliance, new values, and a sense of faith regained. Housing is just one of these needs; all have to be addressed in a true approach to ministry.

It is not just in the twenty-first century that we see the church losing its vision. The same was true when Jesus was here. The people in the church were too concerned about religious debate instead of performing the Christlike deeds they were supposed to be performing. No wonder people were driven out of the temple (Luke 9) after their heated religious disputes. Jesus also angered the guardians of traditional religion so much that they picked up stones to throw at him—a not uncommon last resort to settling disputes, even today.

When self-serving blindness and falsehood are exposed to the light of truth, or when self-interest is threatened, or turf, territory, or resources are impinged upon, individuals and gangs pick up knives,

bats, chains, and guns to settle their differences, whereas nations shoot missiles or drop bombs. At the temple, the Jewish religious authorities called Pharisees picked up stones, but Jesus, we are told, hid himself and escaped.

The church has a mission to help the poor and marginalized. The Bible told us of a beggar outside the temple who had been blind from birth. He had been shunned, bypassed, and rejected. He was forced to beg to survive. To appeal to the charitable whims of others was the only way he could eke out a meager existence.

The good and proper religious folks who went in and out of the temple couldn't help but notice the beggar, but they didn't see him except as an object in their peripheral vision rather than a subject of their attention. They were sure it was neither an accident nor an illness that had caused the beggar's blindness. He had been born blind. Therefore, God must have had a reason for bringing this man into the world in his sightless condition, they thought. His blindness must have been the result of God's curse—God's punishment and judgment for some deep, dark, secret sin. The man's disability itself, according to this religious view, bore witness to some sinful, deviant, degenerative faults in the man's family line. So by assuring themselves that the man's blindness was the condition that his sinful self deserved, the good and proper folks could feel better about themselves and their moral superiority.

Even the disciples bought into this interpretation. They asked Jesus, "Rabbi, who sinned, this man or his parents, that he was born blind?" The disciples, like Christians today, were engaging in religious profiling. They were acting out of assumptions based on the beggar's physical condition. They were passing judgment based on the man's blindness rather than his true essence. His actual blindness superseded, indeed eradicated, his essential humanity.

Jesus answered his disciples' question by saying, "Neither this man nor his parents sinned; he was born blind so that God's work might be revealed in him." Jesus rejected the religious rationale for rejecting the blind beggar, saying in effect, "Stop blaming the sinner to make yourselves look and feel good; look to God, to what God can and will do." Jesus was urging the oppressed to try again.

We have people in our world today who are considered cursed sinners; they are judged and punished by the church for their handicaps. Some are condemned to poverty and rejected by the pious and proper, the self-regarding and self-satisfied, but these folks exist to reveal the glory and power of God!

The very people who we are bypassing and judging to be unfit and unworthy are chosen by God in Christ Jesus as special vehicles of revelation. The poor, blind beggar was not an unseemly lump but rather an enlightening lamp. He existed not to be relegated to the dark corners of rejection but to be a lamp of living flesh in the world that would reveal God's light.

We have the poor and sick people of our cities sitting outside our churches to reveal what those on the inside do not yet see: God's deliverance, God's redeeming grace, and God's healing power.

God cares more about the lives of people than the rules of religion. That's why Jesus healed the blind man on the Sabbath. "Look," said the blind man in essence, "I don't know what you church folks are talking about. That's your field. I know only one thing, and it's all that matters: I once was blind, but now I can see. Case closed."

How long will it take us to accept that the church of today is not doing enough? This being the case, we need to turn to God in true repentance for our sins and ask Him to help us do the things we are called to do.

Chapter 12

Accepting or Rejecting That Zero

Are you looking for acceptance in your environment? The need for acceptance affects people of all ages, races, social strata, and creeds. All of us at one time or another have felt the need for acceptance—for someone to lend us an ear, to offer us reassurance, and to understand us as a person.

The world is filled with millions who are hurting, disappointed, sad, sick, and tired. *Rejection, fear, defeat,* and *frustration* are words that characterize the conditions of many. Today, many look for acceptance but in the wrong places, which leads to dissatisfaction.

Acceptance is a powerful feeling; however, the lack of it can be very painful. Acceptance is a feeling of belonging, of being associated with other human beings. However, the failures and shortcomings of our lives have a way of making us feel vulnerable, rejected, and frightened. Have you ever felt this way?

Problems, situations, and conditions can have adverse effects on our lives, which may make us feel rejected. Perhaps we feel rejected by our peers because of our physical appearances, races, or religions. Changes of environment, such as attending a new school, taking a new job, or moving to a new neighborhood, city, or country can bring us a sense of rejection because we leave old friends behind.

The Bible offers many comforting words that remind us that God doesn't want us to feel rejected. Isaiah 41:10 reads, "Fear thou

not; for I am with thee: be not dismayed; for I am thy God: I will strengthen thee; yea, I will help thee; I will uphold thee with the right hand of my righteousness." In spite of our alienation from and rejection by other people, God wants us to deal with the obstacles preventing us from accepting others.

God understands us better than we understand ourselves. We have the assurance we are never alone because God is always with us. So, whether we are young or old, single or married, or a child with parents or an orphan, and whether people are treating us badly, there is someone who accepts us for who we are. This person is Jesus Christ. He is the best friend we can have. He is a God of empathy. Do you feel accepted by and grateful to God for His loving, kind, and understanding attention?

There is no room in Christ's kingdom for any bias—social, economic, religious, or intellectual. God's love is for all people, and we need to realize that and discard prejudice. It is imperative to understand as a people and as a church that God is no respecter of persons.

In American culture, one acquires racial identity at birth, but being a student of the Bible and anthropology, it is my strong belief that race is not based on biology or simple ancestry. Race is a cultural category rather than a biological reality.

Most churches, for example, believe their congregations include biologically based "races" to which various labels have been applied. These include white, black, Euro-American, African-American, Asian-American, and Native American. We need to understand these racial labels are created by humans to deflect attention from the truth of the gospel, which makes it clear all people are the same in the Creator's sight.

As a servant of God, many times I am grieved at the bigotry that can be found in our world but more especially in the church. Shame

on us! This should never be among the ranks of those who call themselves followers of Christ. The recognition that we are followers of Christ should be the beginning point for acceptance of others. If ever a people had discriminated against other races, the Jews had. Their position as God's chosen people had brought on a pride that caused them to look at everyone else as beneath them. Nevertheless, God used Peter to bridge the gap of racial tension in the early church, of which he was a part. Later, Peter came to the sober realization that God loved other peoples (Acts 8, 10).

Racial division was present in the early church, and even a disciple such as Peter had to break down his wall of prejudice. Peter opposed bringing Gentiles into the church because of their nationality. Peter was probably still living his life based on what God had said centuries earlier when He charged the Jews with staying away from heathen practices of other peoples, especially idolatry. It is easy to see how people can use the Word of God to validate their prejudices; Peter did just that to the Gentiles. His concern was for a moral purity that later turned into a racial hatred for some of God's children.

We must be careful to avoid the same pitfalls. We are guilty of racial injustice whenever we assume one group is better than another. We are called and commissioned to maintain the integrity of the gospel, but we must not turn it into an attitude of spiritual elitism.

People will always have differences; that's part of being human, but we should not dismiss the truth that God loves Jews and Gentiles, rich and poor, and black and white; furthermore, it matters less that people might see us in a totally different light than how God sees us. Obviously, there is a call being extended to our communities of faith to deal with people who annoy and hurt us, but how do we deal with these people? We must act with love to the meanest of people around us. We must choose to take it upon ourselves to treat

them well, show them respect, and be concerned about their needs. It is one thing to say we love God, but it must be demonstrated with our loving actions.

In his book *Spiritual Life*, John Westerhoff echoed the call for racial acceptance when he wrote, "The spiritual life—'Love the Lord your God with all your heart, and with all your soul, and with all your mind, and with all your strength'—and the moral life—'Love your neighbor as yourself'—are directly related."(p. 1)

It would be fruitless and dishonest to deny that prejudice exists among Christians. It is in that context that we hear Westerhoff reminding us we should not think of ourselves as somehow a little better than others because God doesn't judge us on the basis of race.

We can argue that the body of Christ is a diverse group, so we should involve women in ministry. The issue of gender should not be creating havoc as it is doing in our churches and congregations. We are stewards of God's creation. Some people are born with better opportunities culturally, socially, and economically, but we were all made in the likeness of our Creator. On that basis, we should dissipate any prejudices on the issue of gender.

The issue of gender is very important to ministry in the twenty-first century. We still live in a patriarchal society in which men are the leading interpreters of the Bible. They are still quoting the apostle Paul's writings on gender issues, which portrayed women in a subordinate position in society. But it is impossible for males to love God and exclude women from preaching and sharing the gospel; the two behaviors are not compatible. I have worked as a minister and a public school teacher in other cultures for many years with males and females and have found that the prejudice of gender still inflicts our schools and churches.

Our acceptance in the church must grow out of our love for one another. The problems of gender dissipate when we all realize what

their cause is and who our common enemy is. Our cause is the gospel of Christ; our great enemy is Satan and all the evil he stands for.

What You Can Do about Acceptance

- Feel content about yourself in general.
- Do something for others—give them a smile, express a kind word, or share a thought from the Bible with them.
- Learn to talk to others and be a good listener.
- Show empathy as you focus on other people and their interests.
- Forgive those who hurt you, and make amends.

Acceptance can become real to all who struggle with sin and failure. The reality of acceptance comes not from ourselves but from Jesus Christ and what He did for us. He, who is God, became man. When we look in our environment, we see that all is not well, but a glance at Jesus Christ reveals how differently things can be when we admit our failures to treat others fairly.

Our goal in life is to accept God's salvation. We are no longer strangers when we accept God's gift of salvation; we become brothers and sisters. Jesus wants us to identify with others by our demonstration of His love to others. Jesus wants to identify with us even in the midst of our failures and sufferings.

Chapter 13

Help for Those at Their Wits' End

I remember one Halloween on Sunday morning in 1995 when I left home for a 5:00 a.m. morning prayer service at my church in the Bronx. On that Sunday morning, the streets were empty of vehicles, people, even animals. I stood quietly at the bus stop looking in eager anticipation for the BX 9 bus. The morning was cold and windy, and suddenly I heard the sound of men treading like horses toward the bus stop where I was standing. By this time, I had an eerie feeling something was about to happen; I was the only tailor-made target standing at the bus stop for this band of teenagers determined to "get paid," which was their way of describing robbing someone.

Suddenly the bandits were down on me. I remember hearing them say, "Give us your money! Give it up!" I yelled for help as they shoved me to the ground and began to stab and beat me with their knives and clubs. One of the boys told me to shut up or he would shoot me. My attackers were wild and merciless; they had fun punishing me because they had Halloween masks over their faces. I cried for help, but no one came to my rescue. I became afraid for my life because I was one against many. I nonetheless wrestled with the boys until I finally got one on the ground and told him he was going to pay for all they had done to me. The others realized after almost ten minutes of trying to hurt me that I would not give in, so

they ran. Shortly after, the bus came to my rescue; my time of help had come when I thought there was no way out.

We all feel at one time or another that the Lord has somehow forgotten and given up on us, especially the times when we needed Him the most. However, that is never the case. No matter the severity of our problems, Christ is bigger than us, and He has the power to deliver us from any situation. The Devil had realized I had woken up early for prayer service and wanted to hinder me from going to church, but even if I hadn't been going to church that morning, the Lord had given me a reason to praise Him.

Even though I was outnumbered ten to one, God still allowed me to grab the ringleader, which caused the rest to flee. We don't have to run from fights we didn't initiate because God is always nearby to help us in our struggles. The good news of the gospel is that God is with us and never gives us more than we can bear.

One of God's special people, David, was faced with a difficult situation; he had to fight a giant. Through his story we discover the battle belongs to the Lord and we should just stand aside and let God fight our battles. Let's begin by looking at David's situation.

David's Situation

Israel was at war with the Philistines, who were known for their military strength in war. But in the providence of God, David rose from the obscurity of a shepherd to win the approval of the masses to go to battle with a champion, Goliath. There were more-capable men in Israel to fight Goliath, but God wanted us to learn these principles of warfare.

In 1 Samuel 17:18, David was called on by his father to carry supplies to the captain of the army. David knew his country was in trouble. With respect, he saluted his brethren and tried to press the issue that God was calling him to fight this nine-foot-nine giant.

David's father and many others thought David was not a good match for Goliath, who, according to the Bible, could make people flee just by his presence.

Cowardice doesn't have any place in the kingdom of God. We are called to be brave soldiers in the army of Christ. How dare we run from a man we weren't given the chance to confront? That was David's argument. God's children are not supposed to run from a fight they did not start. We cannot allow people who are taller than us or who have power or military training to make us feel insignificant. We can always win the fight when we allow Christ to fight for us. Christ never lost any battle. He won the battle in the beginning when He overcame light with darkness, and He did so again when He conquered death by rising triumphantly. The best warrior is Jesus. "And if God be for us, who can be against us?" asked Paul in Rom. 8:31.

We don't have to be bothered by those who tell us we don't have the gifts or potential to succeed in what we are called to do in life. David's father, brothers, and many others did not realize he was destined for greatness. We, however, should realize Christians walk by faith, not by sight. People will have a hard time discerning our attitude if they don't have a close relationship with God.

There will be times in our lives when we will have to address the giants in our midst. David addressed the Philistines' champion by referring to him as an uncircumcised Philistine; David was telling the giant to shut up! News reached David's eldest brother, Eliab, a soldier in Israel's army, that David had insulted the giant. David's brother became upset and was ready to cast blame on David for leaving the wilderness to come to the battlefield. Little did Eliab know that David had been sent by God to acquire training as a soldier in the wilderness and that his time to exit the wilderness had come.

God wants us out of the wilderness, a place of training. That was true of Jesus, Moses, and Paul. They spent time in the wilderness

discerning the will of God for their lives. Moses' wilderness experience prepared him to be one of the greatest lawgivers in Israel's history. The same can be said of St. Paul, who went into the Arabian wilderness and became one of the greatest New Testament missionaries.

Don't get discouraged in your wilderness, wherever it is. David was a shepherd in the wilderness, but greater things were in store for him. God wanted not so much to change that vocation as He wanted to expand it to make David the national shepherd, the king, of Israel.

That was David's situation. What situations have we faced from which the Lord has helped us? The Lord helps millions the world over who are suffering from diabetes, drug addiction, legal difficulties, accidents they have suffered—the list goes on. God specializes in our situations no matter how far we have plunged into them. God offers us escape from any situation that confronts us and will do so even when we are misunderstood by others.

What Happens When the War Is On?

What happened to David? God helped him kill the giant with a stone (1 Samuel 17:41–50). God came through for David; He made good on His promise. David's story reminds us that God allows us to win the wars raging in our lives without the use of any physical weapons. We need to know the battle belongs to the Lord and He will come through for us.

With God there is always a way to prevail in the midst of a war. The following lessons can be learned from 1 Samuel 17:

- We may be disdained or belittled by others because of our age, religion, gender, or career, but God looks beyond such characteristics and asks us to look for people of His spirit, people who will trust Him even when the war is on.

- Don't worry about people who brag about their physical strength; they should not intimidate us because physical strength is no match to the power of God. Physical strength cannot fight spiritual battles.
- Spiritual warfare must be entered for the right reasons. The focus is not to prove what we know or what we can do but to trust in God, who knows the outcome of every battle.
- Patriotic soldiers fight for their countries, but faithful Christians live and die for Christ.
- Christians must always be about the Lord's business of waging war against the Devil to strip him of any title of championship he would use to intimidate us.
- The Christian weapon is the Word of God.
- There will be spectators around when the war is raging, but once we get hold of the champion, the rest of his followers will disperse. Look for their return! Be on your watch!
- We must aim at crushing the head of the enemy. Once we tap into the enemy's headquarters, the war will turn out in our favor.

May the Lord continue to help us as we battle the powers of darkness. We have already prevailed by the blood of Christ in every situation not because we deserve to prevail or to be helped but so that we may be an example to the world. God wants His Word to strengthen us as we fight the Devil. May God make us firm and indissoluble with the sword of the Spirit with which He promised to help us.

Chapter 14

If Zero Is All You Have—Still Try!

Our days on earth are numbered, and our time rests in God's hands. Sooner or later, we will have to give account to God as to how we spent our time on earth. To each of us, God has given gifts and talents. Some people are more talented and gifted than others, but we all have talents and gifts with which we must honor God.

God does not create us for our own sake but for His glory, so none of us should be saying we don't have anything to do with our lives. We are never too old or too young to find what we are capable of doing. I tell my students that if they study a new word every day, they will have a vocabulary of 365 new words at the end of the year. Studying just one word per day may look like nothing, but it certainly adds up.

Some may say they can't study or dislike memorizing things, but they will never know what they're capable of doing until they try. At one point in my life, English was one of my worst subjects in school. Part of my dislike for this subject was due to some of my teachers who showed no passion or enthusiasm for English. I told myself that if the teachers were not interested, I didn't have to bother. This changed in college; two English professors suggested I major in English. Although I trusted my professors, I didn't major in English, but I began to read and write more extensively on my own. Sure

enough, by doing so, I felt better about myself, and my bitterness against my past teachers dissipated.

God has a way of making us proficient in the things we think we want to have no business with. Most people start out disliking certain subjects but end up majoring in them and becoming masters of them. Others who never liked a particular neighborhood find out it's the place where God wanted them to be.

Had someone told me fifteen years ago that I would write a twenty-page paper, not to mention a book, I would have laughed, but I have learned all things are possible if we try. It is only through practice that we will acquire experience and a better understanding of our mission and purpose in life. There is just so much that can be done in our society, but it all boils down to the individual ready to take risk. The person who desires to learn to swim cannot do it by just talking or reading a book; swimming involves getting into water.

Don't waste your time waiting for something magical to happen in your life; the formula for success is trying. Every second of your life is valuable. Those of us who are always trying different things know that it comes with a price many people aren't willing to pay. For instance, we need patience to try again.

When I was growing up, I did not have the opportunity to travel constantly on a plane. Still, I used to say that I didn't like long flights. I came up with many excuses to defend myself. But in the summer of 2002, I flew for more than twenty hours to the South Pacific. It was then I realized a twenty-hour flight is not as tedious as I had thought.

We cannot just talk about the impossible; we must also look out for the possibilities of life. One of my friends got married in her early twenties. The young woman loved children and tried for more than ten years to have one, but her husband had some form of impotency. My friend was shattered by the news and continued to

spend thousands to make her dream a reality. Things did not happen, but she never give up on God or her husband. She's now in her late thirties; she wrote me recently that she had given birth to twins.

There are going to be times when we try to do things but don't see instant results. In such times, we should always pray and never give up on God. Our time is not God's time; He knows what's best for our lives, and He won't give us more than we can bear.

Trying again is an adventure for Christians whether they want it to be or not. We must be always looking, always on the move, always in transit, and never at home. The Bible makes it clear that "this earth is not our home, we're only passing through" (Hebrews 11:16). We are looking for a better country, a heavenly one; we are not settlers but pioneers. As Christians, we are called to live lives of adventure. Today must be an adventure for us. We don't need to wait for tomorrow to do something new; we need to begin today.

It's easy to follow a set pattern in life. Everybody does it at one time or another. For example, you probably get out of bed on the same side every morning. You may take the same route to work each day and eat at just about the same time every evening. Most people develop habits unconsciously, never really realizing what they are doing. Habits are almost always based on past experiences. If you do something a certain way and find it works, you'll have a tendency to do it the same way the next time, and the next time, and the next. Before you know it, you're in a rut.

There is nothing necessarily wrong with habits (except that they may be boring); they do make things easier. Once you have established a pattern, it is quicker and often more efficient to do something the same way every time you do it. It requires less energy and less thought—you function automatically.

However, habits and patterns can at times get in your way of succeeding in life. Just because something worked for you in the

past doesn't mean it will work now or in the future. If you want to succeed in life, you must be prepared to change the way you do many things. God is a God of newness who doesn't want you to develop habits that may limit your potential to become the person He wants you to become.

Sometimes, our problems will seem difficult if we approach them the way we have been doing for many years. When we limit ourselves to only what we have known or done in the past, we may miss the goal of life altogether.

The Fisherman's Formula of Trying Again

One of my favorite stories in the Bible is in Luke 5, in which Jesus called His disciples to move from occupation to vocation, to abandon the tools of their trades to follow Him.

Peter, James, and John earned their livings by casting their nets into water and hauling out fish. On one occasion, their net earnings had been zilch! They had fished all night but had caught nothing. The disciples had come to shore and were washing their nets, getting ready to go through the same tedious chore again and hoping for better results. A few more nights of the same net earnings and they would be wiped out!

Jesus came on the scene, followed by a sizeable crowd eager to hear Him preach and teach. Jesus saw the boats and their owners; He knew times were very hard for people in the fishing business. Jesus climbed into the boat, and Peter no doubt welcomed this novel diversion from his lousy night of fishing.

The boat became the floating lectern from which Jesus spoke to the crowd. The echo of His voice bounced off the water, which provides an effective natural public address system. When Jesus was speaking, He turned His attention to Peter. Like others on the scene, Peter heard the words and teaching of Jesus, but Jesus was about to

take Peter's occupation and give him a personal lesson tailored to his particular life and livelihood. It was an object lesson in the world of employment and life commitment, a lesson on the difference between immediate profit and gain, between an occupation and a vocation, and between a job and a calling.

Jesus entered into and transformed this particular moment of the interview by addressing Peter's desires as well as his disappointments. Fishing was Peter's life, his living, so obviously the way to get to Peter was through the fishing medium.

Peter's fondest dream, like that of any fisherman, was of a really big catch! Conversely, his biggest disappointment was what had just happened—working all night and catching nothing. For Peter and all fishermen, a full net evoked pure joy, but an empty net elicited frustrating heartache.

Jesus said to Peter, "Put the boat out farther into the lake, where the water is deep, and let down your nets." The moment for Peter to try again had arrived. Even though he was convinced it would be a waste of time and effort, Peter complied with Jesus' request, casting aside his own assumptions and expectations in deference to Jesus. No doubt, Peter had already said, "Master, we have toiled all night, my partners and me, and we've caught nothing. Yet if you say so, I will let down the nets," but Peter resumed his work in resigned obedience, this time in the presence and with the help of Jesus.

What an occupational difference that made! What a career turnaround took place! Immediately the old grind was transformed into a miracle of grace; Peter experienced the fisherman's dream. Peter and Jesus pulled in such a huge catch that the nets started to break and the boat started to sink. Lord what a catch! How sweet it was! Fishing didn't get any better than that! In the presence and with the help of Jesus, Peter experienced an occupational fulfillment beyond his wildest imagination and his fondest dreams.

However, in that moment of unsurpassed occupational fulfillment, Peter also experienced a personal transformation; his vocation was about to change; a transformation had taken place. Having reached the pinnacle of success for a fisherman, Peter had the gnawing suspicion there was something wrong; he needed something more. He must have thought, "Is this all there is?" It was a great catch, but still, it was only a boatload of dead, dying, stinking fish! In that moment of recognition, the fish odor no doubt became stronger than Peter had ever noticed. No doubt Peter thought to himself, "You know, this job really stinks!"

The story is told of a CEO of a large corporation who decided to take stock of his life by participating in a week-long spiritual retreat. At the final general session, each participant was asked to say a few words. The CEO spoke of his long struggle to be a success. He told of the long hours, the tough competition, his burning ambition, and the little time he spent with his family. He enumerated the many rungs he had climbed on his way to the top. "Now that I'm there," he said, "it isn't what I thought it would be. I feel empty inside. It's lonely at the top. This week I've come to the conclusion I propped my ladder against the wrong building."

That's the way it was with Peter. The miracle catch had given Peter all the fish he could possibly want, but instead of producing occupational satisfaction and vocational contentment, the magnificent haul revealed to him only that his life was running on empty. It would take more than a good day's fishing to change that recognition.

But right in there, in the midst of a sinking, stinking boatload of flopping fish, Peter slid down before Jesus and said, "Go away from me Lord, for I am a sinful man" Luke 5:8. What he was saying was, "Scram, Lord, for I'm a miserable sinner—my vocation tells it, but you're holy. Get out from here, Lord, before I contaminate you and

drag you down to my sniveling, sinful level." Peter acknowledged his guilt in being a sinner ashamed to be in the presence of the sinless, holy Jesus. What a contrast to contemporary reactions to sin and guilt in America!

The story of Peter is one with which many of us can identify. Like Peter, many of us are still busy at our occupations, but at the end of the day, we have nothing to show for all our hard work. Some of us are encountering disappointments from all angles while hoping and praying for the big catch. The big catch is possible only when we admit, as did Peter, that we are failures; then we can invite Jesus into our boats.

Perhaps your life has become a sinking boat and all you see are the waves trying to swamp your life. There's no need to be afraid— the expert lifeguard is onboard. There's no need to drown in your fears and worries when Jesus is just waiting for you to say, "Lord, I have failed, and I want a second chance."

Would you like to be successful at your occupation? Would like to experience the fisherman's dream of having a successful night at sea? Would you like to be in a boat with Jesus? Do you have a desire to do more, to see more, to be more? If that is what you want, you will have to be willing to take the risk of putting Jesus to the test. God promises that the risks will always be worthwhile. If you want to try again at your vocation, if you want to see your failures turned into successes, you have to do what Christ commands you to do—let down your net.

Even though Peter encountered tragedy and disappointment as a fisherman, he was able to overcome them with Jesus' help. You should not let tragedies and disappointments stop you from doing your job. Disappointment and tragedies are part of trying again. Like Peter, we all have duties we must perform. The storms of life will rage, the billows of the sea may be dashing against us from all angles, but we must remain faithfully at our stations in life.

You are probably familiar with the phrase "When a man is down, keep him down." What does that mean? A simple answer is that many times as Christians, we find ourselves in some hold-down situations, and not many will volunteer to lift us up. These are the days when we have people and circumstances that are competing to hold us down.

The Christian life can be compared to a boxing ring—we're in a fight with an opponent whose job it is to punch and knock us down. But even when we are down, we are not out. We have a chance to get up and fight again.

You may be under attack by the Enemy. The Devil and his imps may have been assaulting you, and you're wondering if it will ever get better. Perhaps you have been talked about, or are sick, tired, worn out, and depressed. You've been ostracized by friends and told you'd never make it. Your finances are not in order. You've been down and heard it so long that you wonder, "Will I always be on the bottom? Will I always be left behind? Will I ever do any better than I am doing right now?" Don't let these things hold you down under any circumstances. You are a child of the most high God, and nobody can hold you down but yourself.

When you're down, your situation will look gloomy. People who are down don't look or talk the same way as those who are up. The Devil is seeking to get you down and feeling discouraged and defeated, and he wants to keep you in that situation. Thank God, the Devil is a liar! I know I am speaking to some people who are down spiritually. Some of you have believed the lies of the Devil and are down. Satan has told some of you that you have thrown it all away and will never get back what you've lost. He's a liar! The Bible tells us plainly that we can come back when we are down. In the eighth century BC, Israel fell to the Assyrians while Micah ministered to Judah. Micah told of both the good and the bad of those who

walked with the Lord. The prophet admitted his sins as the sins of the people with the phrases in verse 8 and 9, "when I fall" and "I have sinned." In verse 8, Micah mentioned the troubles of Judah with the expression "when I sit in darkness."

The Assyrian soldiers were surrounding the city. Fear had filled Jerusalem, and defeat seemed inevitable. But listen to the expressions of trust in verse 9: "He will bring me forth to the light." You may be down at the moment, but this too will pass! Some of you have troubles coming from every angle and are wondering how much more you can bear. Some of you are feeling down and feel you cannot go another day. You are wondering what you'll face next. You've been flooded with troubles from every side and are asking yourself, "Will I ever get up again?"

Isaiah 59:19 tells us, "When the enemy comes in like a flood, the Spirit of the Lord will lift up a standard against him and put him to flight." My dear friends, the anointing of the Holy Spirit is still available; it will let you raise a standard against the enemy who has been keeping you down. Be not dismayed—the time of your victory is here.

Micah had lost his joy and wanted it back. Being down gives you a wrong spirit. Thank God, things don't have to remain the same way! God still loves you. Satan is a liar, and no matter what you have done or how far you've fallen, God still loves you and wants to be in a right relationship with you. For great sin, there is great grace. You will rise again!

To those at your ground zero, arise and declare,

> Who shall separate me from the love of Christ?
> Shall tribulation, or distress, or persecution, or
> feminine, or nakedness, or peril, or sword? As it is
> written, for thy sake we are killed all the day long;

we are counted as sheep for the slaughter. Nay in all these things we are more than conquerors through him that love d us. For I am persuaded, that neither death, nor life, nor angels, nor principalities, nor powers, nor things present, nor things to come, nor height, nor depth, nor any other creature, shall be able to separate us from the love of god, which is in Christ Jesus our Lord. Amen. (Romans 8:35–39)

Chapter 15

You Can't Let an Ant Outsmart You

Throughout the Bible, God used the animal and insect kingdom to speak to humanity. In Isaiah 1:3, He used the ox and the ass. In the Gospels, He used a rooster. In Numbers, He used a donkey to speak to Balaam. In Proverbs, God mentioned many special members of the animal kingdom. The one that sparks my interest is the story of the little ant in Proverbs 6:6–11.

King Solomon had a word of caution for those living at ground zero. He told how God used the little ant to send a clear message to those who were lazy, idle, and careless. I believe there is much to be learned from the little ant.

Facts about The Ant

1. The ant, a little creature with six legs, is the most successful of all social insects. There are over 11,000 different kinds of ants.

2. Ants live in colonies numbering from a few to over 20 million. There are approximately 1 quadrillion ants in the world (this is ten followed by fifteen zeros!).

3. The majority of workers in the anthill are female! The same is true of the church! We need men to step up to positions of leadership in the church.

4. The only mention of the ants in the Bible is in Proverbs 6.

We can learn many things from ants.

- Ants work in partnership.
- Ants work in love—they don't fight.
- Ants help carry burdens and injured neighbors and rescue those buried or those who have fallen into a pit (Galatians 6:2; Romans 15:1).
- They operate in harmony. One weak, but many strong. Each has a job, but none is more important than another. (We are in this together—we are all members of one body: 1 Corinthians 12:12–27.)

This is not about me; it is about Him. There is power in unity! The members of the early church arose in unity, in oneness. They put away petty differences and disagreements and stood together in the power of the Holy Spirit, and the gates of hell trembled in their presence.

In the ant's world there is a special ant, the driver ant; lions, elephants, and poisonous snakes all flee when the driver ant is on the move. Other important ants are the soldier ants; they kill ants that refuse to work. Another important ant is the honey pot ant. He eats himself full of nectar to feed the rest of the nest. He is a blessing to all. All the ants work toward a common goal, to protect and provide for the colony, especially for the queen.

The ant's work is productive; they all volunteer service. They don't have a guide, yet each ant works. Thousands may dwell in a colony, but every one pulls his or her weight; they work! We have guides—pastors, evangelists, teachers, the Bible, the Holy Spirit; we have everything to get the job done for Jesus, but sadly, some refuse to labor for the Lord. Each job in the church is important, and God's work needs workers willing to use their gifts, large, medium, and small, to serve Him.

Ants work continually, all day. They don't get pay, promotions, thanks, or pats on the back, yet they work. Ants never get mad. Ants don't quit, and they never go on strike! They just work. Believers need to work in spite of hindrances. People will destroy anthills with their feet, but the ants immediately build them again.

It doesn't matter who or what is trying to destroy your work for the Lord; it's time to build it back. If you don't believe ants are productive, just spill a little sugar on a countertop. Any ant that finds it will return to the colony and return with hundreds. Ants keep going in times of danger; they don't have the "We can't" attitude. Hunger motivates ants and gives them purpose.

We believers need the same resolve as ants have; we need to purpose in our hearts that nothing short of death will tear us away from working for the Lord. Let nothing stop us from praying, giving, witnessing, and reading the Bible.

Ants have wisdom; they make provisions for life. They collect food and build their cities. They prepare for the future by storing up when and while they can. Grasshoppers, on the other hand, make no preparations, and when the winter comes, they die! Ants by instinct prepare for winter, just as people prepare for life through building savings, buying insurance, and planning for retirement.

What about death? Much more important, life after death? People need to be ready. Lost persons, are you ready? Christians, are you ready to stand before God? The ant teaches us that we are to wake up, and I would like to think we are at least as wise as the ant. Are we? Ask yourself,

1. Have I made preparations for the future? Am I saved and ready to meet Jesus?

2. Have I gathered all the provisions I need to walk with God today, including prayer, the Bible, fellowship with God and believers, and so on?

3. Am I in fellowship with the members of my church?

4. Am I doing the job Jesus saved me to do?

5. Am I laboring for Jesus, knowing that the darkness is swiftly approaching?

Chapter 16

Zero Down Payment

Ho, every one that thirsteth, come ye to the waters, and he that
hath no money; come ye, buy, and eat; yea, come ye, buy wine
and milk without money and without price. —Isaiah 55:1

He that believeth on him is not condemned; but he that believeth
not is condemned already, because he hath not believed in
the name of the only begotten Son of God. —John 3:18

Verily, verily, I say unto you, He that heareth my word,
and believeth on him that sent me, hath everlasting
life, and shall not come into condemnation; but is
passed from death unto life. —John 5:24

Many of us have visited a court of law and remember how the judge
summed up the evidence given for and against the accused. Romans
3:28 gives us a picture of a court setting, and it also sounds like the
final words of the judge before he passes the sentence: "Therefore
we conclude that today, we are not in the court as visitors, we are
there as the accused standing in the dock and waiting the verdict.
The moment that you have been waiting for has arrived. The verdict
is ready. What shall it be? Guilty or not guilty?"

The judge is now ready to speak—listen up!

"Sin must be paid for. That was what I told Adam in Genesis 2:17, 'In the day thou eatest thereof thou shalt surely die.' Everyone knows that I am the only judge in this world who does not tolerate sin, because "the soul that sinneth, it shall die" (Ezekiel 18:4). Furthermore, 'The wages of sin is death' (Romans 6:23).

"There are many denominations present in this court—Baptist, Methodist, Catholics, Pentecostals, Seventh-Day Adventist, Mormons, Jehovah's Witnesses, Presbyterians, Disciples of Christ, Moravians, and many more. Many have been baptized and have even used baptism to confuse my people. Don't you think I have heard all about your baptism and the great controversy about the method and name that should be used in baptism? What is your quarrel about, that people have to be baptized in Jesus' name and filled with the Holy Ghost before they can go to heaven? There are others in my court who were baptized in the name of the Trinity and believe everyone else is going to hell.

"I speak today also to those of you who are debating constantly about infant baptism versus adult baptism and sprinkling versus immersion! I speak also to those of you who have made New Year's resolutions to turn over new leaves in your lives, and by so doing you have realized you are now reformed but not born again. Many of you are good professors, but you have not possessed true righteousness. Now, ladies and gentlemen, here is the verdict—I, God, and the jurors of heaven conclude you are all guilty of sins of the first degree and will be sentenced to life imprisonment without parole."

People of all denominations present at the court begin to weep.

Do you see the predicament with which we were faced in God's court? Paul sums it up for us in Romans 3:23: "For all have sinned, and come short of the glory of God." The words "come short" simply mean "to miss the mark." The important thing is not by

101

how far we have missed the righteousness of God but that we have missed it.

Many believe they are saved because they attend church, work miracles, cast out demons, and speak in tongues, but there will be a great deal of disappointment for some of them when they meet Christ. Read Matthew 7:21–23 and notice how many people profess to have salvation when they were really far from the kingdom of God.

> Not everyone that says unto me, Lord, Lord, shall enter into the kingdom of heaven; but he that doeth the will of the Father which is in heaven. Many will say to me in that day, Lord, Lord, have we not prophesied in thy name? And in thy name have cast out devils? And in thy name done many wonderful works? And then will I profess unto them, I never knew you: depart from me, ye that works iniquity. (Matthew 7:21–23)

Jesus is giving us a note of warning. We must get our acts together before it's too late! Will we take heed to work out our salvation with fear and trembling? Jesus is speaking to all of us—"good" people, "moral" people, church members, church officers, bishops, pastors, prophets, priests, and preachers—none of us is exempt. "Take heed, lest you fall" are St. Paul's words to us. We should all make sure we have salvation.

Often in our church, we sing, "O when the saints go marching on, O Lord I want to be in that number." I particularly like the phrase "I want to be in that number." Those who seek heaven need salvation to get there. You cannot be in God's number unless you have salvation. That is a prerequisite, your ticket to heaven.

However, many will have you believe they are in this number when they are actually outside the kingdom. In the first-century church was a man who would be admired in today's society—Judas Iscariot. He worked miracles in Jesus' name. He was like the other apostles; he preached the gospel and saved people. He was sent with the rest of the eleven to preach, heal, and cast out devils (Matthew 10). Judas was a preacher, a prophet, an apostle, a treasurer, and a man many admired. Here comes the difference, however; he was not in the number, nor was he saved. He was in the early church and held prestigious positions, but he was wicked. In the end, he hanged himself.

Sin with its guilt has caused many like Judas to commit suicide—but all those who have committed suicide because they thought they were not strong enough to bear their burdens and take them to the Lord in prayer will be haunted by their decisions when Christ returns to judge His people.

We have to be very careful about whom we imitate. Jesus should be our example. What about those in the early church who had Judas as their role model? We should not want to be like someone else because he or she is a good preacher, singer, or example of humility—that's not it! These people can be Judases.

Satan's plan is to marshal the forces of evil to destroy our lives, but salvation has made the difference. Sin cannot overcome the holiness of God. Sometimes, it seems we are losing the battle God has placed us in, but we can't lose something God has already won. Jesus has already conquered sin. The primary reason for Jesus' going to the cross was to pay for our salvation. Jesus died alone; everyone deserted Him during His loneliest hours. The disciples fled for fear they would be killed; even Peter denied Him three times, and Judas betrayed him. Things got so gloomy that Jesus cried for help from His Father: "My God, My God, why hast thou forsaken me, why

art thou so far from helping me?" (Psalm 22:1). Do you think His cry was in vain? Jesus was pouring out His soul to God while He was still a man—what an example for us today! When troubles come upon us, we must cry out to the God of our salvation!

By salvation, we are declared free from the bondage of sin and death. We know the Devil is constantly after us and will use enticing but worldly words and things to trap us. Read Matthew 4 to learn about Satan's temptations of Jesus. Satan even quoted the Bible. If the Devil went as far as putting the King of Kings and Lord of Lords to the test, he will try to do the same with God's children.

Nevertheless, in our times of testing, God will make a way of escape for us. "There hath no temptation taken you but such as is common to man: but God is faithful, who will not suffer you to be tempted above that ye are able; but will with the temptation also make a way to escape, that ye may be able to bear it" (1 Corinthians 10:13). Look at that verse carefully. God did not say that we would not be tempted or that things would not go wrong; instead, He said that when the Devil tempts us, He would provide a way out. Shouldn't we be encouraged that there is a way out of all our problems?

Some of you are going through difficult situations in your life and do not want to bear them, but here, Jesus is saying you cannot avoid the issues in your life and you should not contemplate suicide because you are indeed able to bear it. You can bear losses of jobs, friends, houses, investments, or marriages. Job had a miserable time when the Devil got permission to harass him, but he bore it, and the God who rewarded his faithfulness will do the same for you.

We need to remember we were found guilty of sins in God's court, but God made a way of escape for us. This escape is not a way of living a trouble-free life. No—that's not what it's all about. Paul said we're guilty of the sin of omission (Romans 3:10–12, 17–18),

those things we have left undone that we ought to have done. Paul also said we are all guilty of the sin of commission, things we have done we ought not to have done. When our case was presented to the righteous judge, Jesus Christ, He realized we were all guilty. As a matter of fact, we had all deserved death; instead, Christ provided a way out for us. He realized something had to be done, but none of us who stood guilty before Him could pay the debt of sin.

Think about failing a test and having to repeat a grade. The same is true for all Christians—we have failed the test God had given us. Adam was the first student in that class. He was doing pretty well until pride got up his sleeves. Eve told him God was hiding wisdom from him. She told him he could become smarter by taking a bite of a fruit God warned them, "Thou shalt not eat, and if you eat, you shall surely die." When we refuse to listen to God, He will punish us.

God's rules must be followed. He said, "Do not take a bite of that fruit," and that's precisely what He meant. This rule applies to us today; we shouldn't take a "bite" of stealing, lying, fornicating, being adulterers, being hypocritical, or being greedy. Whatever God has in store for us He will bring to pass. Yet, often, we don't have the patience to wait. None of us should have to listen to someone telling us to neglect our roles as parents—that was what Adam did. Adam's job was like that of a parent; he was charged with taking care of the garden of Eden, his home. Look at the mess he caused in his house by listening to his wife instead of to God.

Husbands, listen to your wives, but draw the line. If your wife is going to tell you to sin against God, you have a biblical duty not to listen. Peter said, "It's better to please God than man" Acts 5:29.

The garden of Eden was a schoolroom at which the master showed up to teach Adam, but the minute Adam took the bite, all communication was cut off. Adam had Eve beside him at school;

he knew the right answer because God had already given it to him: "Do not touch or eat of this tree." Eve conned Adam into believing her lie, and Adam didn't have the right answer. Don't change your answers when God has given you the correct one. Don't erase them; stick with them! And remember this—if you're a smart student, don't let the person beside you do your work—do it yourself! God had given Adam an exam, but when the exam was graded, God told Adam he had had the correct answer but had changed it. Perhaps Adam said, "If only I had known!" But it was too late.

God was upset with Adam for changing the right answer to the wrong one and thus passing on the wrong answer to everyone else in the class—the world. What a shame. Not even one of us passed the exam. We must admit we had an excellent teacher, Jesus Christ. He told us exactly what to study for and what would be on the exam, but our carelessness has caused us to do our own thing, and in so doing, we have all failed.

I had one student who averaged fifteen on a test and another who averaged sixty-four when the passing grade was sixty-five. The two students were in the same predicament; they both failed. It didn't matter that one missed passing by one point while the other missed it by fifty. In the same way, it doesn't make a difference if you swear, gamble, fornicate, and steal while someone else commits just one of these sins. We don't have big or small sins, just sins. Jesus said, "For all have sinned, and come short of the glory of God." However, God sent Jesus to pay for our sins. Jesus did not pay half price, neither did He place our sins on layaway; instead, He paid for our sins in full on the cross.

The Jews of old taught that the only way to go straight and keep straight was through observing all the laws laid down by the elders. These, however, had grown greatly since the days of the original Ten Commandments to a very complicated system of dos and don'ts in

thousands of varieties and in which the don'ts far exceeded the dos. Is there any help from the Law? Yes, there is. The Law makes us aware of sin. In Galatians 3:24, Paul says, "The law was our schoolmaster to bring us to Christ." The Law therefore is a means to an end and not the end in itself; Romans 3:20 tells us, "By the deeds of the law shall all flesh be justified."

If we are to rightly divide the Word of Truth, we cannot be one-sided in our approach to Scriptures. For the perfect answer, we have to turn from the Old Testament to the New. In it, we find the new law of faith, John 3:16: "For God so loved the world that He gave His only begotten Son that whosoever believeth on Him should not perish, but have everlasting life." Our guilt is therefore taken away through faith in the one who loved us and gave Himself for us. We don't confess our sins to earthly priests; rather, we confess our sins to God and accompany that with a sincere desire never to engage in those sins again. Because of His great love and mercy, God will forgive us of our sins and cleanse us of all unrighteousness (see 1 John 1:9).

God provided the zero down payment for our sins and accepted us because of the absolute provision He made for us. There is nothing beyond our reach. We don't have to do anything to earn salvation. We come to God based on one condition, having faith, and only we can fulfill it. God has made the way clear for our justification, every possible arrangement for our salvation. All we have has come from Him, and His heart rejoices when in simple faith we give our all to Him (Luke 15:7).

Salvation puts us on the road to holiness that ends in eternal life. Many would have you believe salvation is not based on choice, but it's so simple to see man has a choice to choose to live one of two completely different lives; we can obey the voice of God or the call to sin.

Sin is a form of slavery—it keeps you submissive to evil. Take a few minutes to mediate before you go to sleep; sum up all the things you have done wrong today. You will observe that you had the choice to say yes or no to these things. However, when temptation came, despite the voice of conscience, you may have fallen to that temptation. If your mind is set on sinning, you won't have time to ask for any power to control yourself; you will just enjoy "freedom" from having to consult or obey, but you are called to trust and obey.

We can choose to live lives of holiness. We must commit all we have and are to Christ, and He should become our Master and we His slaves. Let us pray that the Lord will give us power to overcome the sins of this world, and let us also fully commit our all to Him. Think about a zero down payment for a car of your choice—you can choose between a new or an old car. Those of us who know some of the many troubles an old car is prone to will choose a new car. The same is true with Christ, who wants the best for us. When we accept Christ, He will change our nature and make us new.

Paul said, "Therefore if any man be in Christ, he is a new creature: old things are passed away; behold, all things are become new" (2 Corinthians 5:17). Living a new life in Christ is far better than the feeling you get when driving a new car.

Many drivers are very good at taking care of their vehicles; they will give it regular washings, tune-ups, and oil changes. Just like our vehicles, our Christian lives should be serviced, but with the Word of God. We Christians need more oil in our lamps, we need to keep ourselves clean and pure, and we need the outpouring of God's Spirit in our daily lives to keep us up and running. Living the new life should not be a strain as it usually is with maintaining and old car. Once we are saved, we will always have an ongoing desire to love and serve the Lord. This is an indication of the new life in Christ. We will always strive to have the mind of Christ. Salvation is

free for one and all; we don't have to be rich to have it. My mother used to say, "If salvation were a thing money could buy, the rich would have it and the poor would do." God offers us a zero-down payment for our sins.

Chapter 17

Please Don't Die at Ground Zero

A few months ago, I was on the phone talking to an old friend about the many things going on in our lives. My friend, who was in her late seventies, wanted to make sure her life was right with God because she was very ill. I prayed with her and told her I planned to see her in several months. Two days later, I was at home working on a writing assignment when the phone rang. On the line was the daughter of my friend. She had called to inform me that my friend had passed away. I stood motionless, transfixed by the news, concerned about the frailty of human life. The news reminded me of what I needed to do in my life. Such news convinced me that God's business requires haste and that our time on earth is very short. I was also reminded that God has a program of redemption for mortal beings who are "of a few days, and full of trouble" (Job 14:1). We cannot avoid death; neither can doctors prevent it. Death is a certainty. For many, death is a matter of ignorance. Nevertheless, everyone asks the question death raises: what is to be done with our lives?

Death will overtake us all, and we need an answer to this inevitability. Jesus wants us to be prepared. In the days of Noah and Lot, people were unprepared for events: Noah alone was ready for the flood, and Lot alone was ready for the razing of Sodom. The coming of Christ is also likened to the sudden appearance of a

bridegroom (Matthew 25). Five of the maidens were ready, having planned ahead, but five were foolishly unprepared. We can see people around us who live careless, easy, and indifferent lives, never dreaming death might overtake them sooner than they think.

However, when we are ordering our lives, we must take into account first the will and purposes of God. What sense does it make to enjoy lives of present satisfaction only to find ourselves with an eternal and everlasting future of regret? That is why it is important we prepare to meet our king. Let us not wait until all our earthly obligations are met or until a more convenient day arrives before we place our lives entirely in the hands of God.

One of the things that troubled Jesus when He was on earth was the fact that so many people were discontented, worried, and unhappy with the many failures of their lives, but this was because their priorities were all wrong. A successful life depends on the things given first place in our lives, and too often, the wrong things are given first place. Such things may be gambling, addiction, and illicit sexual indulgences. But Jesus was not thinking of this: money and food and clothing, which, while good and necessary, are not the most important things in life.

Wrong priorities will give rise to needless worry and anxiety that rob life of the peace and happiness it should have for all. Still, our heavenly Father knows what we need, and He will always provide for us. God doesn't want us to crowd out the really important matters; instead, He wants us to put the most important things, spiritual things, first. He sums it all up in the words of Matthew 6:33: "Seek ye first His kingdom and His righteousness."

We all stand in need of God's help. Romans 3:23 tells us, "For all have sinned, and come short of the glory of God." "Come short" simply means "to miss the mark." The important thing is not how far we have missed the righteousness of God but that we have missed it.

Satan's plan is to marshal the forces of evil to destroy our lives. In spite of Satan's plan for us to fail and go to hell, God offers a way out of all our sins. Sometimes it may even seem as if we are losing the battle God is fighting for us, but we should be encouraged; our battles belong to the Lord. In our times of testing, God will make a way for us. "There hath no temptation taken you but such as common to man; but God is faithful, who will not suffer you to be tempted above that ye are able; but will with the temptation also make a way to escape, that ye may be able to bear it," writes Paul in 1 Corinthians 10:13. Below are some Scriptures to help you as your turn to God for answers about your life. Read carefully and prayerfully.

Scriptures to Help You Move From Ground Zero

Commit thy way unto the LORD; trust also in him; and he shall bring it to pass. (Psalm 37:5)

For this God is our God for ever and ever: he will be our guide even unto death. (Psalm 48:14)

Cast thy burden upon the Lord, and he shall sustain thee: he shall never suffer the righteous to be moved. (Psalm 55:22)

In God have I put my trust: I will not be afraid what man can do unto me. (Psalm 56:11)

Be strong and of good courage, fear not, nor be afraid of them: for the LORD thy God, he it is that doth go with thee; he will not fail thee, nor forsake thee. (Deuteronomy 31:6)

The eternal God is thy refuge, and underneath are the everlasting arms: and he shall thrust out the enemy from before thee; and shall say, Destroy them. (Deuteronomy 33:27)

I, even I, am he that comforteth you: who art thou, that thou shouldest be afraid of a man that shall die, and of the son of man which shall be made as grass. (Isaiah 51:12)

Casting all your care upon him; for he careth for you. (1 Peter 5:7)

There hath no temptation taken you but such as is common to man: but God is faithful, who will not suffer you to be tempted above that ye are able; but will with the temptation also make a way to escape, that ye may be able to bear it. (1 Corinthians 10:13)

Who comforteth us in all our tribulation, that we may be able to comfort them which are in trouble, by the comfort wherewith we ourselves are comforted of God. (2 Corinthians 1:4)

Never Remain at Ground Zero

No one wants to stay at ground zero. No one wants to keep shedding tears and being frustrated, tired, miserable, forsaken, despised, and rejected. We all want to be successful in life; we want to be happy; we want to have success stories to share with other people about our children, families, schools, jobs, and churches. Praise God; ground zero is doing its time only until our Savior returns to gather His children to be with Him in heaven for all eternity.

We all know the failures of this life are due in part to our own disobedience to the will of God, but for even this, God has a remedy. He is going to put His creation together, which has been marred by

113

sin and death. Man was put in the garden to dress and keep (protect) it. Man was supposed to be that protection, but he failed. Praise God that the covering around heaven, the New Jerusalem, will never fail. The forces of evil and darkness, which make us subject to failures and disappointments on earth, can never enter our eternal home.

We will be with God for all eternity. What a blessed hope we have in Christ! Forever and ever, we will be with Him. There will be no need to worry or fret about how successful we will be at our tasks—we will enjoy eternal success. The water from the river of life will flow, the streets will be clean, and the tree of life will bear righteous fruits to heal the nations of this world. There will not be any cursing, night, or darkness; tears will be wiped away. Sorrow, pain, and death will no longer exist. We will get along as a church and as a family because all competition will cease. All things will be made new (See Revelation 21).

As the saying goes, "Poor you!" "Poor Me!" In heaven, there won't be any poor you and me because we'll be the greatest creatures in heaven. We will be promoted for all the failures and struggles of earthly life we have endured faithfully until that day.

Let us think it not strange that life at ground zero is a part of our human experience. Every day, we could meet with danger or delight. Every day is an adventure, a challenge, and a miracle. Every day we must contend with failure or success, with boredom or disappointments. We wonder about the purpose in life or lack of it. We wonder about our common destiny or maybe we have neither time nor interest in contemplating the familiar questions, Who am I? Why am I here?

But those of us who believe in God are comforted because we know God as creator and sustainer. We know we are part of a universe that has order and purpose. We know our destiny is rooted in the marvelous events of the birth and death and resurrection of Jesus.

This knowledge does not always keep us comforted, joyful, or successful. Being a Christian doesn't mean being free from suffering, problems, or failures. In fact, it often means quite the opposite. We are sometimes overwhelmed by what needs to be done, what must be done. Some of us lament the failure of the Christian church to be the powerful witness we think it should be. Some of us are acutely aware of our failures in influencing changes in others, in our communities, and in our nations, but isn't this what our faith is all about? Our consciousness of our limitations—and we are limited—leads us to the cross and the resurrection and the power we derive from them.

Good News

God loves us so much that He sent His only Son to be rejected and crucified so we might have life now and forever. We are so important, so precious, so valuable, that God allowed His only Son to be crushed by the mob in Jerusalem so we might be able to be forgiven and accepted. There is no one in the world more important to God than you, and He has proven that by not sparing the life of even His Son. You are so loved by God.

Have you been rejected? Have you been abandoned or deserted, scorned or insulted? Do you ache from the humiliation of sitting in the swamp alone for so long? There is good news for you! Even though everyone else may have left you, even though you may feel no one cares, the message of the gospel is that somebody has bent down into the swamp and kissed your slimy, wart-covered forehead and has transformed you into a handsome prince or a beautiful princess. You are loved, you are accepted, you are special, you belong!

A Final Word

If anyone is keeping you from succeeding, it is probably you, and unless you do something about it, things will be the same next year

and the year after. We all have a desire to improve ourselves and gain better lives. We wish to survive and succeed, but to be successful in life, we must put our trust and confidence in God. "Trust in the Lord with all thine heart; and lean not unto thine own understanding. In all thy ways acknowledge him, and he shall direct thy path" (Proverbs 3:6–7).

Life means excitement, adventure, confusion, personal challenges, and stress. To succeed, we must know how to trust God. The more we trust and obey God, the more successful we will be in life. A successful life without God is difficult to imagine. Remember that all our problems have solutions, so to succeed, we must ask God to solve our problems and take care of our failures and disappointments.

I have talked about the importance of time in this book, and I want to reiterate it. Time is elusive and tricky; it is the easiest thing to lose and the most difficult to control. As you choose to turn over a new page in your life, it may appear you have more time than you need, but time has a way of slipping through your fingers like sand. You may suddenly find there is no way to stretch the little time left to cover your spiritual obligations. When this happens, many Christians panic and even give up. However, to live the abundant life, you need to begin now to manage your time wisely in the service of the Lord. Time is dangerous. If you don't control it, it will control you.